CW00802129

Dramatic Color
in the Landscape

Dramatic Color
in the Landscape

Painting Land and Light
in Oil and Pastel

Brian Keeler

NORTH LIGHT BOOKS
CINCINNATI, OHIO
artistsnetwork.com

Contents

Supplies You Need

The supplies you need to pursue landscape painting will depend on your medium(s) of choice, and largely on your personal preferences for painting outdoors and in the studio. Following is a comprehensive list of the materials the author recommends (see pages 8–11 for details).

Experiment with various products and equipment to discover your own preferences. The specific paint colors and painting surfaces used to complete the studio paintings in the demonstrations in this book are listed at the beginning of each project.

The author painting from the rocks at the harbor in Stonington, Maine, one beautiful morning in August. The finished plein air study appears on page 82. To see a video clip of Brian painting this scene, visit briankeeler.com.

PASTELS | 36–96 sticks of color

OIL PAINTS | The author's palette includes: Alizarin Crimson • Black • Burnt Sienna • Burnt Umber • Cadmium Orange • Cadmium Yellow (Light, Medium, Deep and Lemon) • Cadmium Red Light (or Cadmium Scarlet) • Cerulean Blue • Chromium Oxide Green • Cobalt Blue • Hansa Yellow • Naples Yellow • Permanent Rose • Phthalo Blue • Phthalo Green • Prussian Blue • Raw Sienna • Raw Umber • Ultramarine Blue • Venetian Red (or Indian Red) • White • Yellow Green (Utrecht hue) • Yellow Ochre

ACRYLIC PAINTS | For toning the canvas, including: Neutral Gray (Utrecht hue) • Burnt Sienna • Raw Sienna

SURFACE | For pastels: Canson Mi-Teintes pastel paper • 140-lb. (300gsm) cold-press watercolor paper • Art Spectrum pastel paper

Options for plein air oils: Canson Canva-Paper, 16" × 20" (41cm × 51cm) or 20" × 24" (51cm × 61cm) • Heavyweight barrier paper or 150-lb. (244gsm) watercolor paper coated with acrylic gesso • Multimedia Artboard • Linen or canvas panels

For studio oils: Stretched linen (fine-weave and medium-weave) • Linen or canvas panels

BRUSHES | Variety of bristle, synthetic-sable and synthetic brushes, including Sablette (by Utrecht) and Silverwhite (by Silver Brush) lines: Nos. 2 (Sablette), 4, 6 and 8 round • Nos. 1, 2, 4, 8 and 10 filbert

OTHER SUPPLIES | Palette • Palette carrier and cover • Portable and studio easels • Palette knives • Solvents and solvent container • Acrylic gesso • Glazing/thinning mediums • Clove oil • Palette knife • Water-filled spray bottle • Two L-shaped corners from a mat board (for a viewfinder) • 20" × 24" (51cm × 61cm) or 18" × 24" (46cm × 61cm) foamcore or Masonite support board with two or four clamps • Sketch pad • Graphite and charcoal pencils • Kneaded eraser • Masking tape • Craft knives • Other useful items for plein air painting (see page 9) • Reference photos

Spring Light—Route 187, Sugar Run, PA
Oil on canvas. 36" × 40" (91cm × 102cm)
Collection of David and Virginia Lovitz, Wyndmoor, PA

Spring is evident in this stretch of Pennsylvania road along the river, with forsythia providing a splash of warm, inviting color as the evening sun dapples the pavement.

Introduction

Painting the landscape presents many opportunities for self-expression, as well as an opportunity to address some of the formal aspects of picture making, and the chance to convey an impression of one's surroundings. For myself, landscape painting was initially a welcome break from the confinement of the literal description required with portraiture, which is among the types of paintings that I do. As much as I admire the fluid portraiture of American expatriate artist John Singer Sargent, it is noteworthy that later in life he found the portrait painting process rather tedious and discovered his greatest joy in outdoor painting trips. I can identify with Sargent's feelings.

The desire to paint without the main goal being to literally depict what one sees may seem odd to the nonpainter. In fact, it is sometimes taken as a prerequisite that the creative (nonliteral) painting process represents some sort of fibbing. But to me, the process of creating images is more akin to the novelist who creates from real life but transmutes those experiences into a book representing a distillation of impressions, and perhaps a higher truth. Taking liberties with color is another way of not being cloistered by the tyranny of the literal and fits in with my general approach. Nonetheless, what is being depicted in my paintings is almost always recognizable, and I think they are purchased and admired for those same qualities. Still, landscape painting offers a chance to focus on the formal elements of design and color and the inherent beauty of paint in a way that is quite unique.

Color is the most expressive tool that artists have in their toolbox.

Color is the most expressive tool that artists have in their toolbox. Often it can serve as our most direct emotional vehicle and likewise resonate with the viewer on a very personal level. Each artist's choices are uniquely his own—subjective and biased—and there is no guarantee of success or certainty of appeal. However, entering into a painting with an open attitude of exploring the possibilities will be rewarded with genuine revelations. Learning to take risks is an essential aspect of being creative with color, and in this book, I will show you how taking those risks—armed with increased knowledge and your own intuition—can lead to lasting visual impressions.

In his seminal book *Landscape Into Art*, art historian Kenneth Clark writes, "Facts become art through love, which unifies them and lifts them to a higher plane of reality; and in landscape, this all-embracing love is expressed by light." To me, this underscores the process of painting landscapes. The act of painting one's intimate impressions of nature—clouds, atmosphere, topography, and so on—becomes a vehicle to honor the uniqueness and validity of our observations. The challenge is to carve this out without adhering to a ready-made path or to another's vision. At the end of the day, however, despite many influences, our own voice emerges.

Materials for the Landscape Artist

Traveling and painting: Tools and practical tips

Painting on location, whether at home or abroad, requires a well-organized portable painting system that you are comfortable with. Consider the artists of yore who had to lug heavy equipment along, with only rudimentary methods of getting around. Paul Cézanne trudged five miles each day from Mount Sainte-Victoire in Aix-en-Provence with his painting equipment in a wheelbarrow. Our efforts today seem cushy by comparison. We can only be thankful for the many modern tools and transportation options now at our disposal.

Included in this section are some of my methods, materials and suggestions for transporting supplies and working outdoors. When traveling, keeping your equipment light is key. As I have developed my own product preferences over time, so will you. In the meantime, experiment with various options to discover the ones you like.

Location materials for oil and acrylic painters

Palette carrier | Painters who use oils or acrylics need a way to cover their palettes so the wet paint can be transported and used on subsequent days. Plastic palette carriers (such as Masterson) are light and reasonably priced, but I've found that some eventually buckle and become unsealable. I now use a thin, flat wooden box which, although designed for holding pastels in a French easel, works perfectly as a palette cover/protector. These strong, durable, inexpensive boxes are available in art supply stores and online.

Easel | I have used various easels over the years, and they all have certain advantages. I currently use a Soltek easel (soltekarts.com), which is strong and compact; even at nine pounds, it is half the weight of a wooden French easel. This nifty easel has over a dozen positions to accommodate standing, sitting in a chair and sitting on the ground. It sets up in under a minute, which makes it ideal for capturing moments when the light is just right. Although pricey, Soltek easels are well-made enough to last many years. Winsor & Newton easels are the next best option; they are quite inexpensive and very light. Their fold-up model (about fifty dollars) is a good choice for new artists.

Brushes | Bristle brushes work very well for covering broad areas. Utrecht's Sablette brushes (filberts and rounds) are soft and allow for detail as well as broad passages of paint. I have been using Silverwhite synthetic nylon brushes as well, which are somewhat more universal. They are more springy and stiffer than the Sablette, but not as stiff as the bristle hog's-hair type.

Generally, it is better to use the stiffer type of bristle brush (such as boar's hair or the nylon that simulates boar's hair) when starting a work. This type of brush holds more paint and enables you to cover broad areas with more ease. The synthetic-sable types are better suited for the later stages of a work when you are blending, fusing or otherwise finessing color or modeling form.

The sizes of rounds I use include nos. 2 (Sablette), 4, 6 and 8. The sizes of filberts I use are nos. 1, 2, 4, 8 and 10.

Solvents | To dilute oil color and for cleaning brushes and palettes, you can carry odorless turpentine, mineral spirits or turpenoid in a small can. When flying, I usually take along a small bottle, shipped with my luggage so I have it ready when I arrive. Check with your airline for their policies on transporting solvents.

Painting surface | I like to carry a pad of Canson Canva-Paper, available in 16" × 20" (41cm × 51cm) or 20" × 24" (51cm × 61cm). Another option is to bring heavyweight barrier paper or watercolor paper (150-lb. [244gsm]), pretreated with two coats of acrylic gesso. You may wish to bring a roll of canvas, stretcher strips and a stapler to make your own canvas on-site, but this requires more work. Still another option is Multimedia Artboard. Because this product is very absorbent, a coat of gesso or Liquin is needed to make it ready for paint. Wind River panels are another excellent option. These archival panels

are made with linen or canvas and glued onto lightweight supports.

Paint | The following colors work well for either oil or acrylic painting:

Raw Umber
Burnt Umber
Burnt Sienna
Yellow Ochre
Naples Yellow
Cadmium Yellow (Light, Medium and Deep)
Cadmium Orange
Cadmium Red Light
Venetian Red (or Indian Red)
Permanent Rose
Alizarin Crimson
Ultramarine Blue
Cerulean Blue
Chromium Oxide Green
Phthalo Green
White
Black

Highly recommended for oil painters only is Permalba White. Winsor & Newton's Griffin Alkyd quick-drying white paint is great for traveling. For tinting surfaces, I usually use Neutral Gray acrylic paint from Utrecht and sometimes Raw Sienna (acrylic or oil) or Burnt Sienna (acrylic). Try different brands to discover your own paint preferences.

Glazing/thinning mediums | An optional item for oil painters, Copal medium speeds the drying of oil paints. Liquin also speeds drying and provides an even final varnish. The medium that I have been using as of late is

Utrecht Alkyd Glazing Medium, which is very similar to Liquin. Clove oil is an option that slows drying, allowing more time for corrections if needed. I only use clove oil in the drawing stage, not while painting.

Solvent container | The best container I have found is a stainless-steel model called the Petite Air-Tight Brush Washer. Clamps keep your turpentine or mineral spirits from spilling while traveling, and a scrubbing device in the bottom allows pigments to settle. Another exceptional airtight model of solvent container is sold by Holbein. A cheaper but less effective option is setting two small aluminum cups on your palette to hold your solvent and medium.

Spray bottle | A small, water-filled spray bottle will help keep acrylic paint wet.

Palette | For plastic palettes, cut a piece of foamcore or mat board to go inside and cover it with aluminum foil. Or, get a premade paper or wooden palette insert.

Palette knives | I very rarely use palette knives for the actual painting process, but I may use one to mix a large quantity of paint. I favor the standard triangular-shaped one shown in the photo on page 11. Early in my career, I would always prepare an extensive palette of about thirty colors and used a knife to mix in clove

oil (which slows the drying markedly). Now, I favor a fast-drying palette and therefore do not pre-mix with a palette knife.

Two L-shaped corners from an old mat board | These may be held up and used as a viewfinder by sliding them in either direction to alter the shape and composition of any prospective painting.

Other useful items | Things you will want to have when working outside of the studio include:

Hat
Folding stool
Camera
Sunglasses
Sunscreen
Tall leather boots if you plan to hike in the open fields; otherwise, comfortable hiking or walking shoes
Case for carrying work
Sturdy tube for shipping work
Paper towels/rags

Location materials for pastel artists

Surface board | I recommend a 20" × 24" (51cm × 61cm) or 18" × 24" (46cm × 61cm) foamcore or Masonite board. Two or four clamps are useful for holding your paper to the board.

Paper | For pastel, I carry ten to fifteen sheets of Canson Mi-Teintes. For watercolor I usually suggest carrying ten sheets of 140-lb. (300gsm) cold-press (I use Arches), which I also

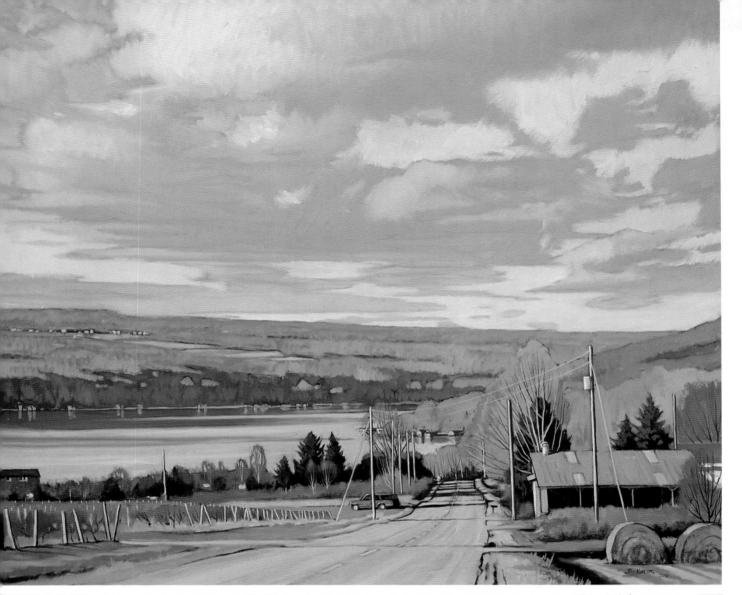

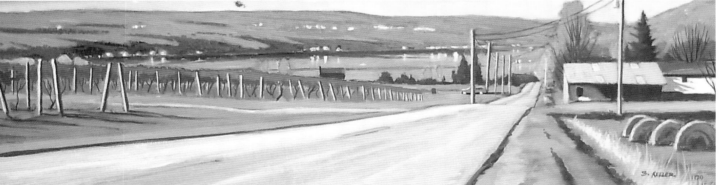

Keuka Clouds

Oil on canvas (studio painting).
40" × 46" (102cm × 117cm)
Collection of Caryl Flickinger, Penn Yan, NY

Keuka Lake, November

Oil on canvas on panel (study).
10" × 36" (25cm × 91cm)
Private collection, Corning, NY

From on-location study to studio painting

I painted this piece mostly on location, on a beautiful, warm Sunday afternoon in early November, and finished it in the studio from memory instead of using a photo reference. The view is of Keuka Lake, just south of Penn Yan, New York, on the eastern side. In the study, the format being a long rectangle, I decided to focus on the land and lake and minimize the sky. The key elements are all clustered in a focal point in the upper right. In the studio painting, I shifted this cluster to the lower right, thereby opening up the expanse of the sky, and zoomed in for a closer view.

recommend for those who wish to apply an acrylic wash before applying pastel. Carry a sketch pad as well.

Art Spectrum is a wonderful brand of paper that I just started using. This paper is very durable, so much so that you can wash out areas that are not working out. You could also use turpentine washes first as an underpainting before using pastel.

Pastels | A Prismacolor NuPastel pack of 96 colors is the traveling set I prefer. It also comes in smaller quantities, including 36, 48 and 60. These nice sticks allow for detail as well as broad coverage of areas. I've also used Schmincke and Rembrandt brands.

Pencils | For pastel work, use 2B or 4B. A variety of charcoal pencils, 2B and darker to 6B, are useful for sketching. Also keep on hand a kneaded eraser.

Masking tape | Masking tape comes in handy for a variety of reasons. One use is to tape down the edge of your paper or canvas sheet to prevent it from blowing or flapping in the wind.

Craft knives | These utility blades (such as X-Acto) are useful for a variety of small tasks, including shaping a pastel to a point or sharpening charcoal and carbon or graphite pencils. The carbon and charcoal pencils are often too soft to be used in a conventional type of handheld sharpener.

My oil palette
My studio oil colors, starting from the upper left: white (usually Winsor & Newton Griffin Alkyd), Burnt Umber, Burnt Sienna, Yellow Ochre, Naples Yellow, Cadmium Yellow, Cadmium Orange, Cadmium Red Light, Venetian Red (or Indian Red), Permanent Rose and/or Alizarin Crimson, Ultramarine Blue, Cerulean Blue, Chromium Oxide Green, Yellow Green (Utrecht) and Phthalo Green. Not shown here are other colors I use that I consider neutrals, including black and Raw Umber. Also, lately I have been using Cobalt Blue or Phthalo Blue, which I would put in between the Ultramarine and Cerulean. Sometimes I add other colors to my palette, such as Hansa Yellow, Cadmium Yellow Lemon and Prussian Blue.

Setting up back at the studio

My palette layout in the studio is not any different from the way it is prepared for my plein air work. This basically consists of arranging the colors around the outside of the palette in order of how they would appear on the color wheel.

The surface I use for my oils painted in the studio is stretched linen (fine-weave or medium-weave) and linen or canvas panels.

When I begin to work in the studio, I like to have my small plein air study nearby, along with any sketches and photo references.

As painters we are always trying to see our work anew and to take in the overall look and progress. In my studio, I have a large mirror mounted on a sturdy wooden easel and located behind me. The purpose of the mirror is to offer a fresh view of the work. Periodically, I will look at the reverse image of the painting in progress in the mirror, where I will sometimes be surprised by the out-of-whack spatial divisions or other anomalies that I couldn't see with a regular view.

Standing while working is also beneficial, especially during the early stages of a painting. Stepping back from our canvas periodically and reassessing our work is facilitated by standing.

getting
better
acquainted
with
color

Approaching color in painting can be
daunting, but given a structure and
familiarity with the main properties,
it will add clarity to your work. In this
chapter we will explore some of the basic
color terms, theories and ideas that will
help us articulate our artistic visions.

Perugian Wall—Last Light
Oil on canvas on panel. 18" × 24" (46cm × 61cm)

This painting of the ancient city of Perugia in central Italy was done on a very windy day on a stairway. The play of light on the wall was what initially attracted me to the scene, and this is what was blocked in quickly at the inception of the painting.

Loading the Nets, Lipari Morning
Oil on linen. 36" × 40" (91cm × 102cm)

Powerful primaries
This interpretation of the docks in Lipari, off the north coast of Sicily, uses a zigzag composition to lead the viewer through the image, with pauses here and there for the viewer to enjoy—a character, a gesture, a color. Variations of yellow, blue and red stand out in this scene. There is a depiction of myself painting on the wall in the upper left.

Color Terms to Know

This basic list will introduce (or reacquaint) you with some of the terminology necessary for relating to color in painting, including the three main properties of color: hue, value and intensity.

Hue | The general categorization of a color (i.e., blue or red).

Value | The level of lightness or darkness of a color, when its range of values is compared to a grayscale. Generally, the lightest value (or white) is 10 on a scale of 1 to 10, and the darkest value (or black) is 1. Some reverse the order.

Intensity | The level of saturation or brilliance of a color, sometimes called chroma. Paint containing an abundance of pure pigment is therefore saturated and stronger (higher chroma). Lessening the saturation in any given hue is one way of controlling intensity. Other ways involve diluting the hue with black, white or complementary hues.

Saturation | This term is related to intensity but refers also to how strong/pure or weak/diluted a color is.

Tint | Any hue altered with the addition of white.

Shade | Any hue altered with the addition of black.

Key | The predominance of dark or light values in a painting. A high-key painting contains mostly light values, and a low-key painting has mainly dark values.

Primaries | The three main hues on the color wheel: red, yellow and blue. These colors cannot be mixed from other color combinations.

Secondaries | The hues of green, orange and violet. These colors can be made by mixing combinations of the primary colors red, yellow and blue.

Tertiaries | The hues located between the primaries and secondaries on the color wheel:

yellow-green, yellow-orange, red-orange, red-violet, blue-violet and blue-green. These colors can be made by mixing combinations of the primary and secondary colors.

Color chord | A system, plan, scheme or organizing principle used to add strength and structure to the overall color approach in any given work. This results in a more unified look and supports a mood. A color chord can be formed by using a combination of two, three or four hues and is referred to respectively as a dyad, triad or tetrad.

Dyad | A color chord that may be formed by using two complements (colors appearing opposite each other on the color wheel) or two near complements (such as red with blue-green or yellow-green instead of green).

Triad | A color chord formed by combining three equidistant colors on the color wheel. Their positions form an equilateral triangle.

Tetrad | A four-color chord that may be formed in three ways: (1) by choosing two pairs of complements whose connecting lines are perpendicular on the color wheel (for example, yellow and violet with red-orange and blue-green); (2) by choosing two pairs of complements that are separated by a single pair of complements on the color wheel, forming a rectangle—for example, the tertiaries on either side of the complements of yellow and violet (yellow-orange and blue-violet with yellow-green and red-violet); or (3) by choosing two adjacent hues and two opposing hues that form a trapezoid on the color wheel (such as yellow and yellow-orange with red and blue-green).

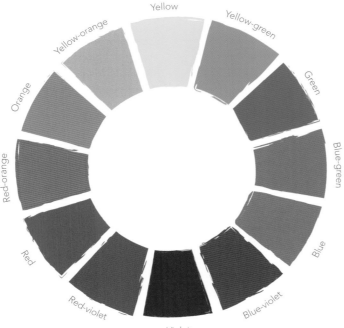

The standard color wheel
The standard color wheel contains twelve colors: three primaries, three secondaries and six tertiaries.

The five-way color sphere
The color sphere concept was devised by Swiss Expressionist painter Johannes Itten and refers to his five-way color-mixing system. It's intended to help you visualize the five principle "routes" you can take to mix variant hues between two complements or opposites (in this case, blue and orange).

Visualize the color wheel as a disc slid into the sphere at its equator. Going around the "equator" requires going through the normal color wheel. Moving from either complement toward the center of the sphere (and therefore toward each other) will neutralize the color. Heading north or south will produce tints (toward white) or shades (toward black); each color will gradually be neutralized or lose chroma progressively.

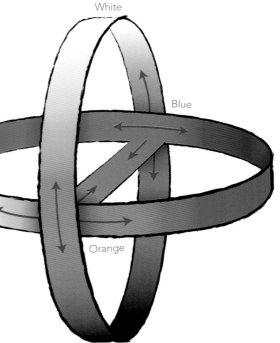

Basic Color Schemes

Some familiarity with basic color schemes—and being able to identify them in paintings and in the observed world—is helpful for the artist, and using them will give structure to the color in your artwork. Color skillfully positioned in key points is often much more sophisticated than using color in abundance and haphazardly.

Here are some basic schemes for selecting and organizing colors in your paintings.

Monochromatic
Just one color with its shades (additions of black) or its tints (additions of white).

Complementary
A pair of colors that are exactly opposite each other on the color wheel. This is one way to form a dyad.

Offset (or near) complementary
One color plus another color that is adjacent to the first color's exact complement. This is another way to make a dyad.

Split complementary
Any one color, plus the two colors adjacent to its exact complement.

Double split complementary
Two pairs of complements that are separated by one color on the color wheel. This is one way to form a tetrad.

Analogous
Any three or four adjacent colors on the color wheel.

Analogous plus complement
A group of adjacent colors, plus one complementary hue opposite the group.

Triadic
Any three colors that are an equal distance apart on the color wheel (for example, the primaries red, yellow and blue).

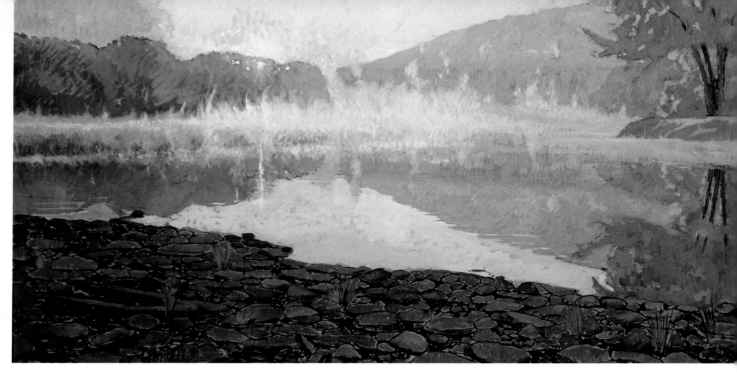

Solstice Sunrise—Susquehanna at the Mouth of the Towanda Creek
Oil on linen. 38" × 54" (97cm × 137cm)

Working with a dyad, using color wheel opposites

I based this largely impressionistic painting on a study I made after waking up at daybreak while camping here on a canoe trip. I used the dyad of violet/yellow but with the addition of other hues, mainly blues, whites and light grays. All the colors are light in value except for the foreground shoreline and a few dark accents else-where. I often use variants of this dyad—in this case, with light values to suggest the ephemeral and atmospheric effects of first morning light on ever-changing mist.

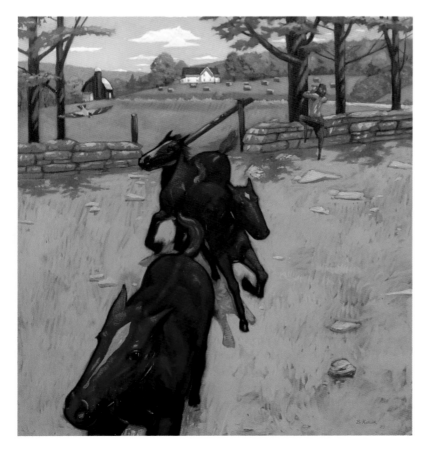

They Galloped
Oil on canvas. 46" × 42" (117cm × 107cm)

Offset complements

In this imaginative scene, offset complements are used—blue-green and a red that is moved toward blue to make it a purple-like Alizarin Crimson. This color scheme was chosen to accentuate the difference between the "normal" lighting in the landscape beyond the wall and the somewhat unexpected lighting in the area between the wall and the viewer. The horses and foreground area were intended to exist in a different type of space, perhaps even a nocturne or some type of hyper-reality. The colors were adjusted to suggest a shift of types of perception.

Types of Color Harmony

A system of harmonizing colors in a painting was first developed and published in 1839 by French artist Michel Eugène Chevruel (1786–1889) in his book *The Principles of Harmony and Contrast of Colors*. Chevruel organized this system into six distinct harmonies of two different types: harmonies of analogy and harmonies of contrast. Here is a brief summary of these harmonies that are still used by artists today.

Harmonies of analogy

Harmony of scale | Closely related values of a single hue are utilized together. Scale in this instance does not refer to size but to keeping the color choices within one hue, hence reducing the scope or scale of the intended system. This classification could be considered a monochromatic system.

Harmony of hues | Analogous colors (adjacent hues on the color wheel, usually no more than four) of similar value are used.

Harmony of a single colored light being dominant | Using a variety of hues but unifying the composition through the use of a dominant colored light—for example, a cool, soft light falling on a scene illuminated by the moon, or a specific color of light shining from a neon sign into an interior room. One could also use lights with filters or bulbs of specific temperatures, with the intention to achieve a single color harmony as a result of the illumination.

Harmonies of contrast

Contrast of scale harmony | Using a single hue but employing strongly varied values. This could be considered a monochromatic system as well.

Contrast of hues harmony | A composition of analogous colors—blue, blue-violet and violet, for example—that are strong in purity and value contrast. All the colors used in this scheme are of a decisive hue, meaning the purity

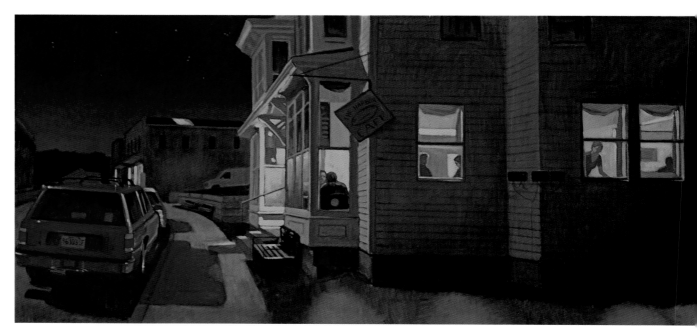

Stonington, ME Nocturne
Oil on linen on panel. 22" × 48" (56cm × 122cm)

Pairing "imperfect" primaries for harmonious color

The color system at work here focuses on blue and yellow; however, they are moved away from the absolute primaries to produce some warm blues, like the Cerulean-like car shadow on the sidewalk. In the sky and elsewhere, the blues are cooler (Ultramarine Blue with Alizarin Crimson). The sky color is kept low-chroma, except as it nears the horizon, where the value is lightened and the intensity increased. The lights likewise are toned down to make them softer than a pure yellow, less intense but still of a light value.

is clear and the colors unmuddied, but the values are distinctly different to show contrast.

Contrast of color harmony | Using combinations of hues that appear far apart from each other on the color wheel, such as complements, split complementaries and triadic colors.

The importance of using a harmonic color scheme can vary from piece to piece. It is often beneficial to the efficacy of a given work to have an idea of the color intentions and organization ahead of time. By setting a structure with regards to color, composition, theme or other aspects, one can learn about the power of limits and the effectiveness of doing more with less. However, a color strategy is not always necessary or even appropriate. For example, when doing plein air work, it may be more advantageous to just record one's impressions accurately, honoring one's perceptions rather than imposing a predetermined agenda.

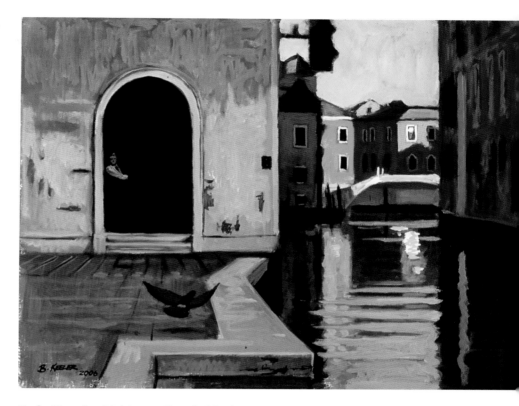

Early Morning Light on a Canal—Venice
Oil on canvas. 11" × 14" (28cm × 36cm). Private collection

Neutral harmony
In this view, I was particularly interested in the light reflecting on the water and the man in the doorway, which reminded me of some of John Singer Sargent's views of dark Venetian alleys. The color harmony in this piece utilizes neutrals. The dark, ambiguous mystery of the doorway, along with the grays and the muted, warm browns in the shadows, form a backdrop for the main event: the early morning light hitting the warm ochres and rusty colors of the buildings, and the light reflecting off of a single window. All form a locus of warm color and the brightest lights in the "sweet zone."

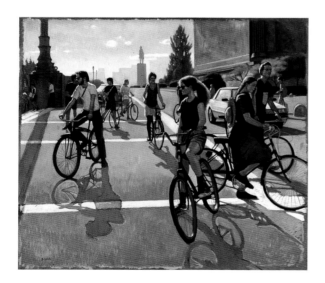

Bicyclists in Front of Philadelphia Museum
Oil on linen. 36" × 40" (91cm × 102cm)
Collection of Patsel's Restaurant, Dalton, PA

Near-complementary harmony
This painting's main interest is the color, and its bicyclists are a vehicle for the chroma play. The overall color scheme is warm, almost hot. I toned the surface with Burnt Sienna and Cadmium Red, visible in the unpainted borders. The color harmony is a dyad of offset primaries: yellow and its near complement, magenta, in the shadows. Both colors are moved away from their color-wheel-perfect hues to give the chosen scheme a little more subtlety than just a yellow/purple combination.

making
color
dramatic

In realistic painting, the goal is to communicate an image, a mood or a concept through the depiction and expression of the visually experienced world. As artists, we must decide how concerned we are with duplicating what we see—in terms of form and shape, as well as color—and how much to alter or invent for a better, more expressive, more dramatic interpretation.

Light on Bales
Oil on linen. 30" × 36" (76cm × 91cm)

Making a decision about overall distribution of shapes and their relationships is key at the onset of a painting. In this work, the light on the foreground is the main protagonist. The vivid sky may take up the majority of the canvas, but it serves as a backdrop and supporting role in the composition.

Considering Color Temperature

Determining the temperature of colors, either in the observed world or within your work, is a very important consideration when painting. Evaluating temperature whenever you select a color will add to the clarity of conception.

Generally, colors that fall between violet and blue-green on the color wheel are considered cool, and those between red-violet and yellow-green are warm. However, just how cool or warm a color appears depends on the context in which it is used and its relationship to other nearby colors. Some violets and certain greens may go in either direction, depending on their usage. Grays may be either cool or warm, depending on whether they veer toward the blue or yellow side of the color wheel.

If the colors you choose are not definitively in either group, they often become weak colors. This is not to say that there cannot be great subtlety and delicacy of color, as when using muted grays and umbers. Still, giving due consideration to the temperature of any color you use will help to strengthen your painting's appearance.

Organizing colors using a two-color system

One way to add a system or structure to the process of approaching color is to determine whether the desired hue leans toward blue or yellow. This idea is inspired by the work of contemporary painter Daniel Greene. As a caveat, however—and unlike Greene's method—any two colors could work for this, if they are far enough apart on the color wheel to make the approach effective. So, the opposites of red/green could form a system, as could yellow/violet. In most of my work, though, the blue/yellow system seems to work best. Almost any color can be assigned a place toward one of these primaries, with the exception of primary red and pure green.

As a useful challenge, randomly select a color from an object you see and then evaluate whether that color leans toward blue or yellow.

Morning Walk
Oil on canvas. 48" × 54" (122cm × 137cm)
Collection of Alexander and Elizabeth Maclachlan, Wilmington, DE

Warm and cool on a chilly day

This frosty New York City scene, painted on a light-ochre-tinted canvas, alternates between warm tones and the arbitrary selection of turquoise-like greens and warm greens. Although the turquoise appears cool overall, it looks warm when compared to the Ultramarine Blue vest. The green wall, having more yellow in it, is even warmer. Purples and mauves can be warm or cool, depending on how much red or blue they contain. I used warm reddish colors in the car and cool lavender tones in the window frames.

Although the colors are engaging, ultimately what makes this piece effective is the tonal contrast of light and dark.

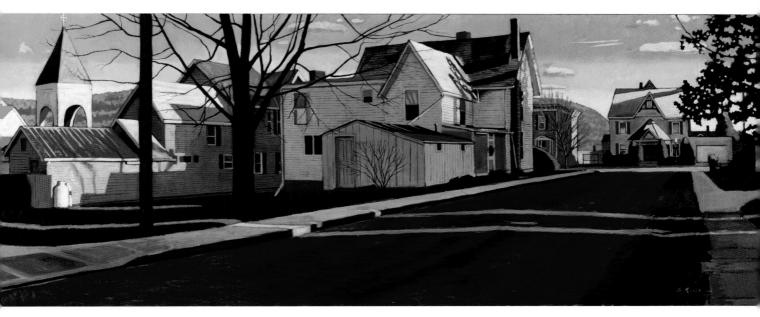

**November Light—
Senate Street, Wyalusing, PA**
Oil on linen. 22" × 60" (56cm × 152cm)
Collection of Moses Taylor Hospital,
Scranton, PA

Color extremes meeting at just the right moment
In this work is my favorite type of light—that transitional, fleeting moment of drama where you see "the crack between the worlds," as Carlos Castaneda describes this numinous time in his novels. I pushed the colors into the extremes of warm and cool using a violet/yellow combination.

Front Street Forsythia—Vernal Light
Oil on linen. 40" × 50" (102cm × 127cm)

Opposite tones and temps energize
The house in the painting belonged to my grandmother. I spent much time playing here and nearby, as our house was just down the street. Here we see the evanescence of spring light, with its warmth streaking across a lawn. The forsythia is the main focus, while the Victorian buildings are secondary. The violet undertone of the canvas, because it is the opposite of yellow on the color wheel, acts as an effective foil.

I applied the paint similarly to the way I apply pastel; the paint quality is often like impasto, or without a lot of solvent, which also makes it similar to pastel. The word *impasto* most commonly refers to a technique where paint is laid very thickly on an area or an entire canvas, so that the brush or palette-knife strokes are visible. You can also mix the paint directly on the canvas. When dry, impasto provides texture.

Embracing High-Chroma Color

The term *chroma* refers to the intensity of a hue. High chroma simply means strong color. The more pure a color is—the more pigment it contains—the stronger the color. Lessening the amount of pigment or diluting a hue by adding black, white or its complement will result in lower-chroma color, or color that is less strong. Painters generally seek a clarity of color or pureness of pigment, and often I seek to express what I see in beautiful, bright colors.

Colors need not necessarily always be of a consistent chroma. In fact, we can improve our body of work by varying our palette. Remember the artists who have achieved success by using minimal or very subtle nuances of color, such as the Baroque artists Rembrandt, Velázquez and Caravaggio.

The process of drawing and painting is often one of making initial studies and then refining or distilling the search for what is most engaging. Choosing colors is a special part of this process that I find liberating and that will allow you to portray the landscape with a latitude or freedom in method and approach. The process becomes less restrictive with an attitude of openness to the potentials of color usage.

To start, it is best to observe the given scene and select what is inherently drawing you to portray this landscape. Then, by honoring your own impressions, seek to bring out or accentuate the uniqueness of your individual perception.

In *The Elements of Color*, Johannes Itten advises his readers to seek to liberate the spiritual essence imprisoned in objects. With that idea in mind, we can approach painting landscapes with somewhat of a higher dictum and purpose. The practical nuts and bolts of achieving heightened hues will come with practice and experimentation.

Winter View Toward the River Valley at Browntown, PA
Oil on linen. 46" × 50" (117cm × 127cm)
Collection of Tracey and Chris Keeney,
Sugar Run, PA

Primary variants for creative color
Red, yellow and blue are the starting-point colors here, but each hue is shifted away from its perfect primary to make them more nuanced and effective. For example, the yellow leans more toward Yellow Ochre or Naples Yellow Hue. The hillside trees are reddish violet (made with Alizarin Crimson, Ultramarine Blue, Burnt Sienna and white). The distant mountains are variations of blue, starting with the cooler and darker blue next to the river, made with more Ultramarine Blue. As the mountains recede they are made lighter in value, and more Cerulean Blue is used.

The important thing in this work is to get these somewhat arbitrary color choices to work in concert. The values or tones have to correspond and read correctly, and pertain to the perceived scene.

Terra Melodia—LeRoy, PA
Oil on canvas. 36" × 40" (91cm × 102cm)

The best color
In part, the mission of the Les Nabis painters of late-nineteenth-century France as well as the Fauvists was to make every color perceived the best and most brilliant. For example, if you see a green, you would try to make it the most intense green possible.

Chroma changes within a painting
The abstract qualities of the land are emphasized here, and the drawing lines of umber paint were allowed to remain. The fields in the foreground were invented to lead the eye in; as one observer noted, fields are not usually cultivated going downhill for soil erosion reasons. However, the rows of corn on the opposite hillside actually were heading downhill. The title alludes to the rhythmic quality that I like to bring out in the patterns of the land.

Note that the shadows cast by the trees, going horizontally across the hill-side, are very muted in chroma, almost neutral, but dark in value. Then, in the upper area, the shadow of the trees takes on a high-chroma blue, illustrating the atmospheric effect of *sfumato*, in which distant scenery appears bluer or smoky. Usually in the sfumato treatments in a landscape, the chroma is also reduced or grayed down; here, it was notched up. In the borders, I am using a variant of a complement of the green, which in this instance is a light Alizarin Crimson and Burnt Sienna combination with white.

Chromatic Expression

In these examples, I am taking the inspiration of nature and aspects of the landscape, carefully looking at what I see and seeking to bring out the best or most descriptive color. Sometimes these subjects appear ready and full of potential. As Georgia O'Keeffe once observed, they present themselves as if already painted. However, most often it requires work to flesh out the essence and reveal the attributes.

Color theorist and educator Faber Birren made this interesting observation about aesthetics in relation to color: "Beauty (or ugliness) is not out there in man's environment, but here within man's brain. . . . The perception of color—including feeling and emotion—is the property of human consciousness. If man is awed by what he sees in his surroundings, he should be far more impressed by what lies within the sanctuary of his own being. Thus where to look is what is important, not in ignorance but in sensitive understanding."

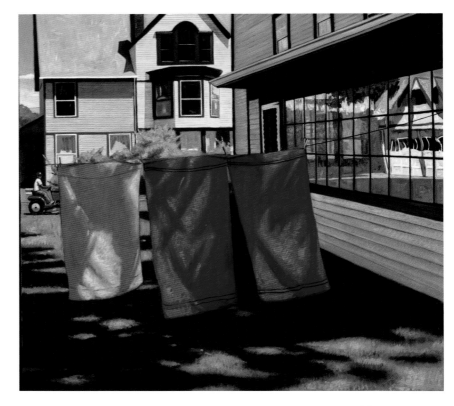

(top) The Observation, School Lane
Oil on canvas. 52" × 58" (132cm × 147cm)
Collection of Chris and Sharon Leahy,
Corning, NY

(bottom) View From the Lane
Pastel on prepared paper.
13" × 17" (33cm × 43cm)
Private collection, Scranton, PA

Saving high chroma for the star of the show

I saved the most intense, high-chroma color for the hanging towels—for the light on them, applying unmixed paint directly from the tube—while using more subdued hues in the background. I contrasted the temperature in the background (warmer) with that of the foreground house (cooler), partly because the sun was shining on the back house. The shadows in the foreground were kept a very muted, dark green. In this case, the value is the most important aspect, as these dark shadows act as a frame to bring out the light and color of the towels. The light/dark relationship between the towels and the grass switches back and forth—in some places, the towels are defined by dark against light, and in other places, light against dark.

Wilmot Township Winter Scene
Oil on linen. 36" × 40" (91cm × 102cm)
Collection of Skip and Ginny DeNeka,
Dundee, NY

Combining blues and earth tones

Here, the cool Cerulean Blue amidst the warmer tones of the earth and trees make for a nice combination. The placement of the trees and shadows was altered to better fit the format and allow for a more convincing progression into the image. Unfortunately, this old house is no longer standing.

Winter Light Through the Orchard—Sugar Run, PA
Oil on panel. 22" × 48" (56cm × 122cm)

Light play leads to color play

In this late-afternoon view, I liked the horizontal streaks of light crossing the road as it appeared to narrow in the distance, creating an intriguing visual dynamic. The unifying light patterns are more exhilarating than anything in particular about the location, and they also help organize the painting.

The beauty of snow and the play of light can provide wonderful inspiration for color usage. In this instance, the interplay is between cool and warm. A tetrad is used for the four main colors in this painting: the complement pairs of violet/yellow and blue/orange. The white of the snow is slightly warm, with some light yellow added, contrasting with the light periwinkle blue shadows.

Fractured Color

One way to add luminosity and variety to any given passage in a work of art is to break up the color, or modulate it. This is sometimes referred to as fractured color, which simply means to vary the color in any given area. For example, for a sky, selecting and interspersing three analogous colors—or several variations or temperatures of a hue—will vary the color and prevent a certain boring regularity. They should remain close in value, however, thereby creating subtle gradations of color for a more sophisticated result.

This fracturing technique works very well with pastels, as the medium is well-suited to applying impressionistic daubs of color. However, it works equally well with oils and other painting media.

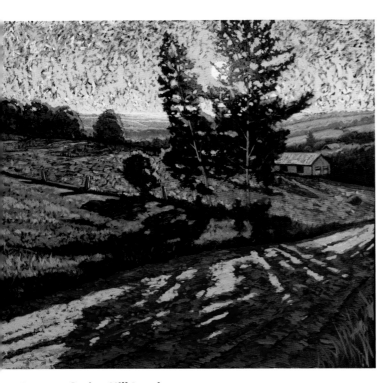

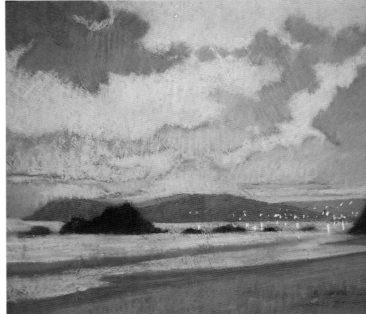

Zihuatanejo Bay Evening
Pastel on prepared paper. 16" × 19½" (41cm × 50cm)

Spring Hill Landscape
Oil on canvas. 46" × 50" (117cm × 127cm)
Collection of Lou Koch, Paoli, PA

Pastel-like strokes on a dark underpainting

The explosion of color and light in this painting is set off by the dark underpainting, which also accentuates the brushstrokes. This large oil may actually have started as a painting that I was not satisfied with, and therefore painted over with a dark mixture (probably Burnt Umber and violet) that was opaque enough to cover the underlying image, so that no "ghost" image or *pentimenti* (Italian for "mistakes," as in repent or correct) would appear. On other occasions after this, I used dark but intense hues as the primer or undercoat. This process of working on a dark surface was not that different from my pastels at the time, which were often done on dark colored paper. As the work was beginning, I applied the paint in a manner similar to the way I work in pastel, with individual brushstrokes left intact and very little blending.

Surface preparation supports color application

The sky in this painting of a Mexican seaside town is where fractured color is coming into play. In the light part of the sky is a combination of pink, light blue and yellow, all applied in strokes of layered color. The fractured-color process is related to Georges Seurat's pointillism, as the colors all kind of mix in the viewer's eye to form a new color, but with a certain richness of texture and subtlety not possible with a flat, single passage of color. The rough surface of this prepared paper (gesso with diatomaceous earth) allows for the strokes of pastel to be broken up easily.

Glazing

Glazes are transparent or translucent layers of thin color used to modify or enrich the color beneath. The paint used in glazes is usually suspended in a medium or oil such as linseed oil. There are many glazing mediums available.

The use of glazes has been one of the applications possible with oil painting that has appealed to artists for centuries. When this glazing technique was discovered and used, the slow-drying process of oils added an advantage of blending and modeling that egg-based tempera (the predominant medium at the time) did not have. The increased richness and strength of color available to artists using oil paint was soon apparent.

There is a certain allure that the use of glazes seems to promise, which is to suggest that they will give any artist marvelous results and beautiful color. However, my best suggestion for glazing is not to have the glazes be the main feature of the painting. Glazes should serve to augment what the painter is doing, rather than be the focus.

Some painters use many layers of glazing medium (Winsor & Newton's Liquin, for example), oftentimes between each day of painting. The process can add richness by bringing out the luster and best nature of the colors, and equalize the sheen. Covering a painting with a layer of medium is especially helpful when certain areas dry more matte, or with less sheen than other areas. (Burnt Umber is particularly notorious for causing this problem.) An application of Liquin or Utrecht glazing medium will even the sheen to a satin-like gloss (not super glossy). Lately, I have been adding a final coat of Utrecht glazing medium at the finish of a painting to accomplish this even sheen and as a protective coating.

New Albany Winter Evening
Oil on linen. 36" × 40" (91cm × 102cm)
Private collection, NJ

Glazing for a glowing sunset
In this painting I used successive glazes to attain the luminous effect of the sunlight coming from behind the barn. I used Winsor & Newton's Liquin, a glazing medium that is about the consistency of petroleum jelly. I suspended sparing amounts of pigment into this transparent medium to create the effects of filtered light.

Glazing over time
Flemish painter Jan van Eyck (1390–1441) is often credited erroneously for inventing the oil paint medium. It was actually in use for several hundred years before him, but in limited scope. Van Eyck's *The Arnolfini Portrait* in the National Gallery in London exemplifies how he took oil paint to an unprecedented level of virtuosity, partly through the use of glazes. American painter Maxfield Parrish (1870–1966) also used multiple layers of thin color glazes to create his trademark vivid and intense color.

Intuitive Color

The use of color in an intuitive way, rather than dictated by system or theory, is an approach that many painters take as standard procedure. Our color selections reflect an innate signature of ourselves and offer a sort of visual fingerprint. Color usage by nature is generally aligned with the emotional and intuitive aspects of our nature, while drawing and line are associated with logic and rationality.

For most of the works you see in this book, the approach that I use is primarily intuitive, allowing for the color choices to assume a flow and natural selection. This is not to say, however, that systems and theories are not used at times. Oftentimes the dominant method, intuitive or by system, will ebb and flow with the given work depending on the needs of the piece. One painter I knew often advocated "asking the painting questions," rather than dictating an agenda. This attitude seems more sensible, as it allows for intuition and lets the needs of the painting speak and be known.

Some believe that the very act of making color a science, in regards to the making of art, is at odds with its fundamental qualities. The work of the nineteenth-century French Post-impressionist painter Georges Seurat comes to mind, as his highly systematized use of color into an optic exercise was perhaps going against the grain or opposed to the natural usage of color. I believe it is better to rely on theories when in need or in a fix. Still, a thorough understanding of color theory and concepts only allows for more tools to simplify the sometimes daunting task of applying color.

The process of using color intuitively can still be pursued and encouraged even though defining it exactly is more elusive. Working on location (doing alla prima painting or plein air work) requires that you paint quickly and spontaneously, which encourages and facilitates the intuitive usage of color.

Browning's Pond—Spring Hill Solstice
Oil on linen on panel. 10" × 36" (25cm × 91cm)

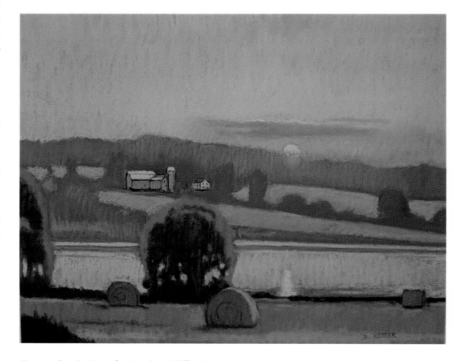

Browning's Pond—Spring Hill, PA
Pastel. 18" × 22" (46cm × 56cm)

The soft pink of sunset

This plein air pastel was completed mostly on a single evening at the same location as the oil version (above). Portraying the same scene in different mediums offers varying insights into the same motif. As the time of day here was sunset, the mystery and softness of this transitional period was best represented with soft-edged, diffuse and blended colors. The pink of dusk and sunset is a particularly attractive color that was fun to portray here. This pastel had one layer of somewhat finger-blended color. Then, the integrity of the strokes applied in subsequent layers was allowed to remain.

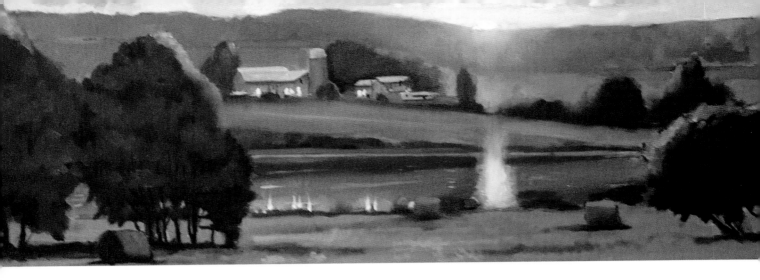

Observation guides intuitive choices

About 60 to 80 percent of this painting was done on location. As with all my work, the composition was the first objective. Then, to organize the values, I sought distinct and clear areas of tonal change. I reserved the high-chroma color accents for where the light was the strongest. The intuitive aspect comes in choosing the hues that express the vision and concept experienced on location. In this case, I used lots of warm green (Chromium Oxide Green and Yellow Ochre plus white) to show the delicate effect of warm light. To convey the topography, I paid attention to the way the light bathed the land, revealing such details as how the hillside angles down to the pond. Back at the studio, I punched up the rust-colored accents near the sunlit water and in the penumbra of light in the trees.

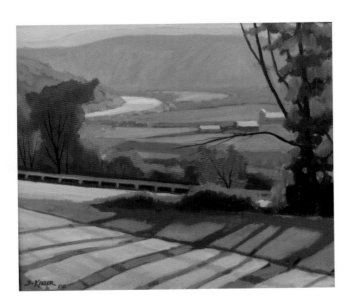

Over French Azilum
Oil on panel. 14" × 16" (36cm × 41cm)

Selectively exaggerate for a stronger image

The study above is setting up all the compositional elements and value relationships, along with light direction. In the studio painting (at right), all of these aspects are embellished or exaggerated. Values were organized more clearly by making the foreground trees and shadows darker. I also made the sumac bushes a distinctly different value than the background. The roundness of the road is more accurately described by the cast shadows, and the contrast on the road is increased, too.

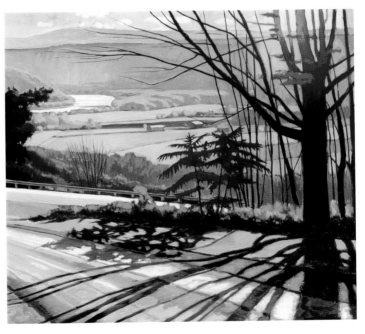

October View of French Azilum With Sumac
Oil on canvas on panel. 44" × 48" (111cm × 122cm)

Arranging and Pushing Values

We have considered the purposeful alteration and manipulation of color and color relationships, but a concern that almost necessarily precedes color selection is value. Although it is the color that is often noticed first, in order for a painting's colors to work for the viewer, the values must read correctly. As the old adage says, "Color gets the credit, but value does the work."

The interaction of light and dark is often referred to as the "figure/ground" relationship, and put simply, it refers to whether the objects described are light against dark or vice versa. If we can simplify into an overall composition an easily discernible figure/ground design with clearly conceived tonal relationships, our artwork will be easier for the viewer to read.

As we work, we often think of punching up the color or accentuating hues, but taking liberty with value (the tones or shades) is another method we should always keep in our arsenal of techniques. Options not often thought of enough are pushing or exaggerating value relationships—and conversely, minimizing value contrast for a softer, more subtle effect.

The best approach is to have fun with color, as long as the values are working in accordance with it. Once the value relationships are working, you have greater freedom to invent and alter color.

Cadis Winter Evening
Charcoal and white pastel on paper. 9" × 12" (23cm × 30cm)

Snow white? Maybe not
This sketch suggests an overall light/dark plan, or "figure/ground" relationship. The value of the toned paper supplies a suggestion of the foreground snow, which is somewhat darker than the sky, even though we think of snow as white. Values are all relative and must always be compared.

The corresponding value relationships of pure color wheel hues
The color we use on our paintings is almost always a mixture, which makes the resultant color and value obtained unique. Still, this grayscale/color wheel comparison provides a useful starting point to begin to understand the values of tube colors (in this case, all Winsor & Newton). Notice that pure white is lighter than the yellow, and pure black is darker than the violet.

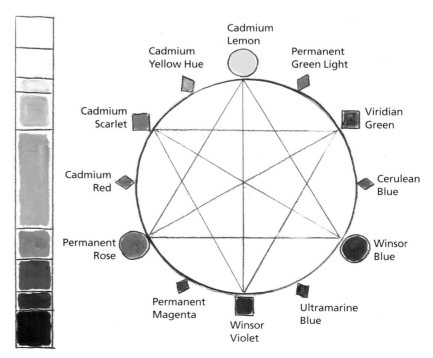

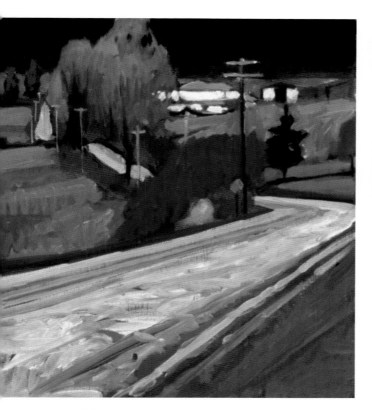

Spring Hill, PA—May Storm
Pastel on paper. 28" × 36" (71cm × 91cm)

Going darker, with definite light direction

Here, the values were pushed darker, most notably on the road. The changes in the pastel result in revealing a light direction, which in turn describes the shape of the road, the roundness of the trees and the lay of the land. The mood quality in this pastel version might be more optimistic, as the light is shining through from the right, even though the clouds are massed on the horizon.

Approaching Rain Storm
Oil on panel. 14" × 16" (36cm × 41cm)

Starting light

This oil study was done on location. Working outdoors provides artists with firsthand experience of nature and light in all its varieties. In this work, the weather conditions provided a drama of dark clouds against the light land and road.

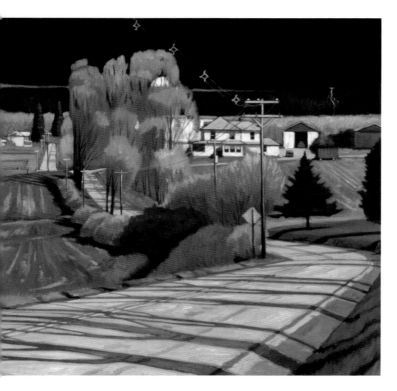

May Storm on Spring Hill
Oil on canvas. 36" × 40" (91cm × 102cm)
Private collection

Pushing the darks and the lights

In this painting, based on the studies shown above, I have pushed the value of the sky to pure black to emphasize the contrast and for dramatic effect. In this final work, I have combined elements of both the oil study and the pastel. For example, the brightness of the road and the white buildings in the oil study are brought into this version. The road is also lightened. However, the color form description from the pastel is also incorporated.

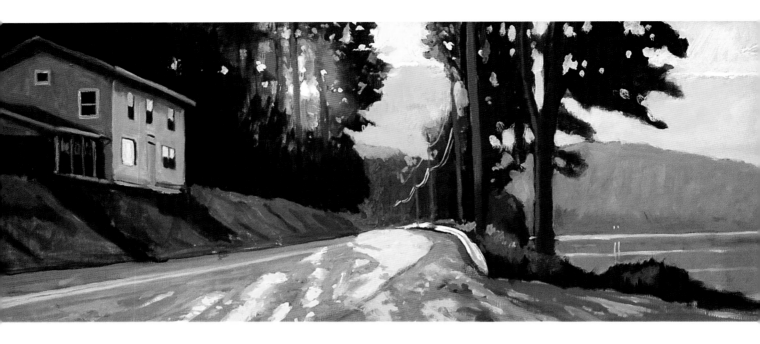

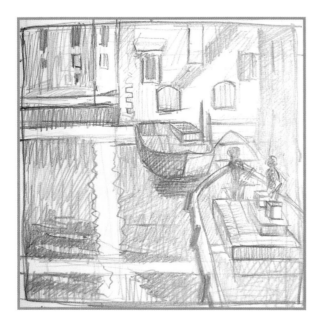

Capturing light patterns and relationships
This 12" x 9" (30cm x 23cm) pencil sketch, done while standing on a crowded bridge in Venice at about 10:30am, was intended to capture the overall feeling of light while emphasizing the relationships between the intervals of light crossing the water.

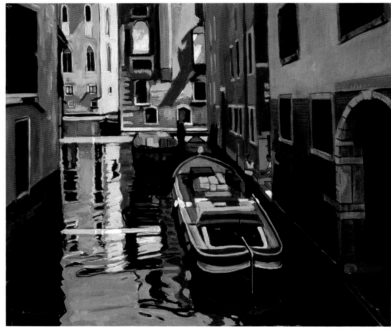

Canal Light, Venice
Oil on linen on panel. 22" × 24" (56cm × 61cm)

Distinct lines of light
The light crossing in three distinct areas on the left—indicated by sharp yellow horizontals—was the main attraction to this scene. The relationships between these slashes of light is what I considered the most important compositional device. The fact that I observed the scene directly and sketched from life helped inform this painting, which was done in the studio.

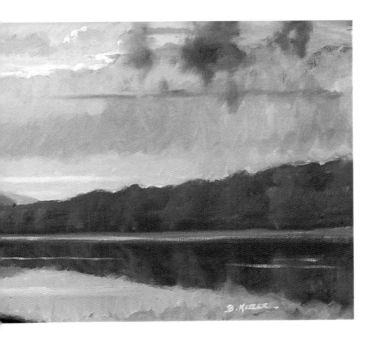

August 4th Landscape
Oil on linen on panel. 10" × 36" (25cm × 91cm)
Collection of Linda Graves, Ithaca, NY

Using darks to zero in on the light

This oil was painted after a riverside bike ride early one summer evening. The spot along the Susquehanna River and the desired time of day had been decided earlier in order to give a focus and goal to my search. In this painting, the dark values are occurring closer to the viewer, as is usually the case; here, they are in the trees on either side of the road. These dark areas of trees act as a type of frame around the house, sun and road. The dappled sunlight on the road is what I considered the main actor of the painting, and the lightest lights and most chromatic color (the yellow and oranges) are occurring there and around the sun.

**Early Morning Winter Light—
Susquehanna Valley at Homets Ferry, PA**
Oil on canvas on panel.
44" × 48" (112cm × 122cm)

Stepping values from foreground to background

This compositional and value plan is what I consider a type of window or doorway device (see page 60). In this view of the river valley, the darkest darks are in the foreground trees, and then the values become progressively lighter in the next group of violet-hued trees. These layers of value become lighter as the eye moves back through the break in the trees to the river and land.

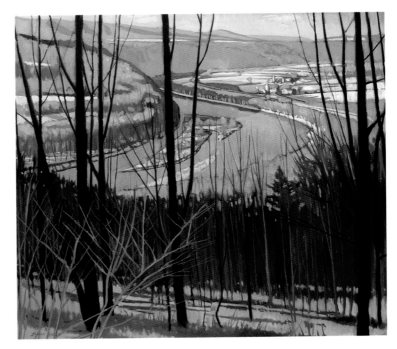

Tuscan Hillside—Barga Afternoon
Pastel on paper. 25" × 17½" (64cm × 44cm)

Late light, deepening shadows
The unifying element in this pastel is the last light of a spring afternoon in Barga, a charming medieval hill town high up in the mountains of northwestern Tuscany. The value plan was to exaggerate the darks in the shadows in the central area to bring out the light streaking across the field and houses in the midground and in select areas near the top. This time of day was the *golden hour*, or late in the afternoon, when the beauty of form and light work together to bring out the best of each.

Simultaneous contrast
This concept refers to using two colors that contrast with each other and therefore bring out one another to greater advantage than the individual colors would have on their own. This concept works best when using complementary colors such as blue and orange. Contrasting values may employ this device as well. When values in a drawing are manipulated to increase the drama, readability or impact of an image, this is also an aspect of simultaneous contrast.

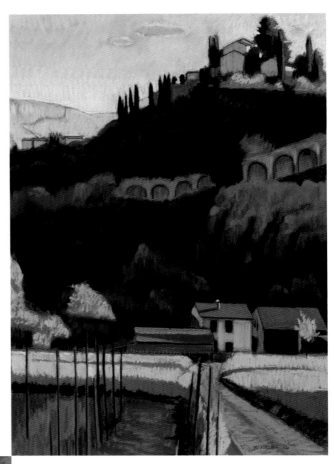

Tuscan Hillside Light, Barga
Oil on linen on panel. 24" × 28" (61cm × 71cm)
Collection of David Zarko, Scranton, PA

Pushing the darks to emphasize the light
In this oil version, done late in the day, the darks were made darker to exaggerate the light. The drama of light helps to carve out the scene into distinct value patterns, and then it is up to the artist to bring out this quality. For example, the darks in the midground (on the wall and hillside of the town) work to silhouette the foreground grapevine on the left. The house at the end of the road is basically a midtone against dark, and the vines are light and midtone against dark.

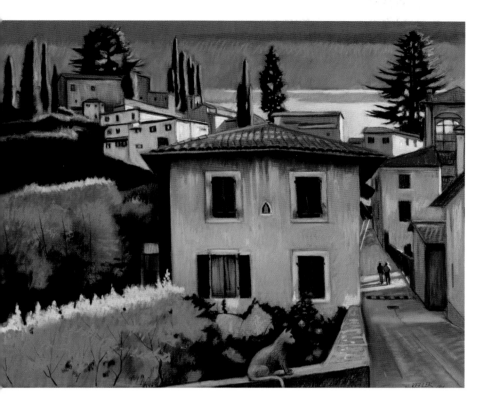

Strada Fornaceta With One Cat—Last Light, Barga
Pastel on paper. 18" × 23" (46cm × 58cm)

From value to value
At first I wanted to do an oil painting onsite, but after dropping my brushes over the steep wall into the garden below, I had no recourse but to await the homeowners' return. To make the most of my time, I did this pastel. The cat was watching a door, from which a woman eventually emerged with scraps of meat.

The house is the focus, defined primarily by virtue of it being a mid-value against mostly the darks around it, although there are other areas such as the roof where the figure/ground relationship switches. Ideally, you want to see an overall value relationship, meaning a simplified light on dark, or a mid-tone on light, or a dark on midtone, etc. However, in the real world, such well-defined organizations are not always available in our chosen motifs.

Morning Light on the Pink House—Strada Fornaceta, Barga
Oil on canvas. 11" × 14" (28cm × 36cm)
Private collection, NJ

Definitive light for drama
I returned to the same spot in Barga two years later to paint an oil, this time in the morning. The sun was shining down from the upper left, creating an engaging pattern of light and cast shadows. The house is again the main actor here, and even more in the spotlight. The value of the house is now lighter in the sunlit areas, which further dramatizes it and contrasts with the dark background.

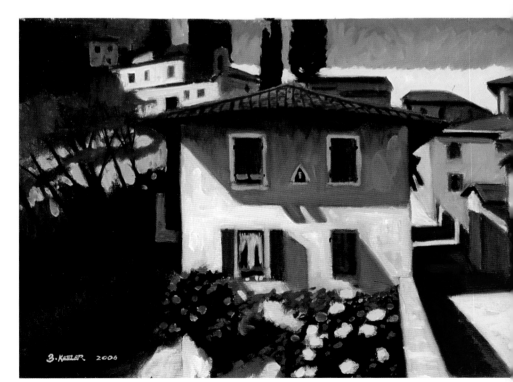

Farmland: Working in High-Chroma Color

This oil painting began as a demonstration for the Elmira Regional Art Society in Elmira, New York. I used several photos that I had previously taken for reference. I later finished the painting in my studio. It may have required another six to eight hours to complete. More detailed and complicated designs would require more time.

My main goal here is to show the use of high chroma (intense colors) in a clarified design of the landscape that incorporates distinct value contrasts. In other words, for these creative color choices that are somewhat of a departure from the local colors, there needs to be differences in the values (relative light and dark).

MATERIALS

SURFACE: Stretched medium-weave linen, 36" × 40" (91cm × 102cm)

PAINT COLORS: Alizarin Crimson • Burnt Sienna • Burnt Umber • Cadmium Orange • Cadmium Red Light • Cadmium Yellow • Cerulean Blue • Permanent Rose • Phthalo Green • Prussian Blue • Ultramarine Blue • Venetian Red • White • Yellow Green (Utrecht)

OTHER: Neutral Gray acrylic paint (Utrecht)

1 Sketch the main shapes and divisions

Tint the surface with Neutral Gray acrylic first. Then start with very simple divisions of space and a quick appraisal of the relationships between the objects. In beginning these types of landscapes, I focus on the design quality and search for the abstract essence, moving back and forth with my arm held out and brush wielded in a loose manner. Take in the overall image and don't become too engrossed in any one detail. This drawing is laid in with Burnt Sienna, but any dark color will do. Indicate the center and the four quadrant points with light marks to assist with placement. Without a center, it is difficult to create an effective rhythm and place key elements.

2 Continue sketching, minding perspective

Further sketch in the basic shapes but without any detail. The eye level here is located in the field just below the buildings. The placement of the eye level somewhere other than directly in the center makes for a better distribution of shapes. The eye level is only implied here, because there is no specific landmark or horizon exactly on the eye level. However, the perspective angles of the roof lines need to take the eye level into consideration in order to work.

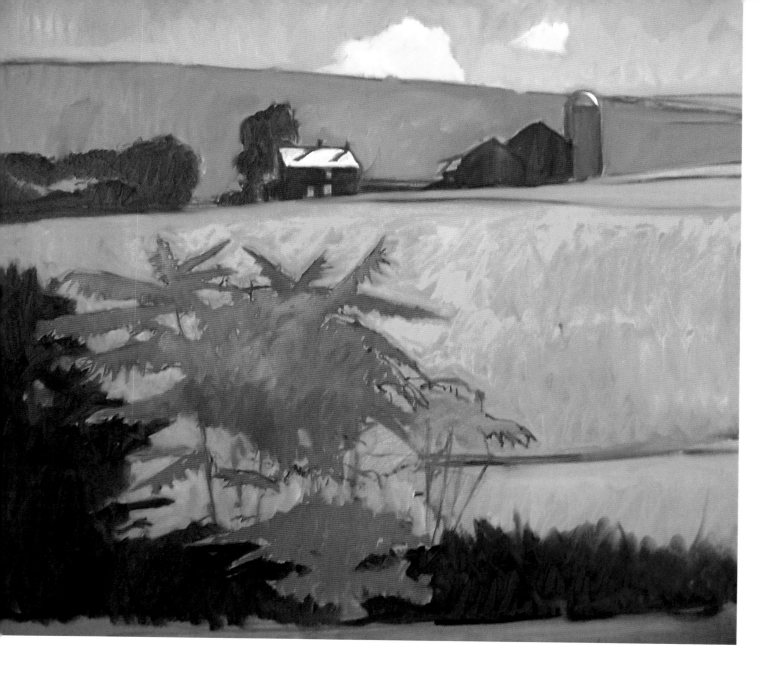

3 Block in the initial colors

Begin to add color, with attention to getting the values to work. Here, the gold of the field brings out the sumac because it is a lighter value. At this stage, the painting is still composed of relatively large flat areas of broad color, with the exception of the house roof and silo, where you'll begin to suggest light direction and forms.

The colors you use need not be restricted to local (or actual) color. You can invent color as you feel inspired, while still maintaining the realism of the image. Since I like to bring out the chroma inherent in any scene, the color here is purposely pushed to more intense hues.

Sky: White with Permanent Rose, some Alizarin Crimson and Ultramarine Blue
Sumac brush in the foreground: Mixture of Cadmium Red Light and Venetian Red
Mountain: Combination of Ultramarine Blue, white and some Cerulean Blue
Large swath of golden field: Cadmium Orange, Cadmium Yellow and white
Green area of field: Yellow Green (Utrecht) mixed with white
Darker green areas of trees and brush: Phthalo Green toned down with Alizarin Crimson and Burnt Umber
Buildings: Ultramarine Blue and Prussian Blue toned down with Burnt Umber and some white

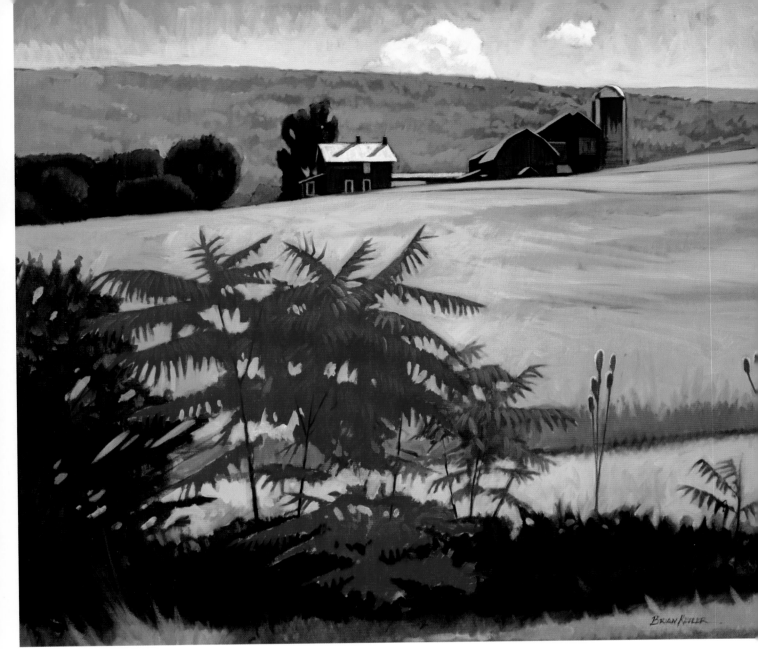

October Sumac, Near Stowell, PA
Oil on linen. 36" × 40" (91cm × 102cm)

Create contrast and dimension with value changes

4 As your painting progresses, give attention to contrasting values. The value relationships are crucial in order to make the objects communicate and the color work. While adjusting colors for clarity and contrast, the other goal here is to articulate form, which means bringing out the topography and the shapes of the buildings as well as carving out the sculptural quality of the trees and bushes by adding highlights and pushing darks to be stronger. In this stage, more white was added to the sky to lighten the horizon. I toned down the blue in the barn and house but also made them darker with more Burnt Umber.

The finished painting—a loose work with clear patterns—retains some of the immediacy of the sketch. During this final stage, I brought out a zigzag or "Z" pattern by suggesting the direction of grain and shadows in the gold field, then veering off to the right and sharply back to the left again with the green sliver of grass in the upper right.

Gorge Waterfall: Developing a Warm Color Scheme

In this gorge scene, our goal is to portray the beauty of light while creating a rhythmic flow through the pictorial space. We want to accentuate the light, and to do this we will choose a more limited palette to bring out the scene's luminosity. A warm color scheme perfectly suits this autumn scene, as well as the late-afternoon light known as the *golden hour*. Glazing will be used for the final applications of paint, primarily in areas of sunlight.

MATERIALS

SURFACE | Stretched medium-weave linen, 26" × 30" (66cm × 76cm)

PAINT COLORS | Burnt Sienna • Burnt Umber • Cadmium Yellow Lemon • Cadmium Orange • Cadmium Red Light • Chromium Oxide Green • Hansa Yellow • Naples Yellow • Phthalo Green • Ultramarine Blue • Venetian Red • White • Yellow Ochre

OTHER | Neutral Gray acrylic paint (Utrecht) • Glazing medium (Utrecht)

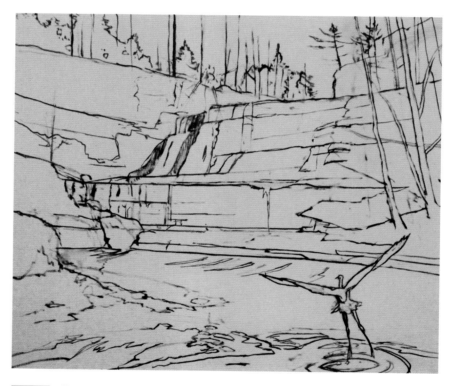

1 Create a rhythm in your sketch
Begin drawing on a canvas tinted with Neutral Gray acrylic. At this stage, work to create a rhythm throughout the canvas. In this instance, it is somewhat of a zigzag pattern, starting with the heron on the right and then working up through the waterfall to the space in the trees, and then back to the sun.

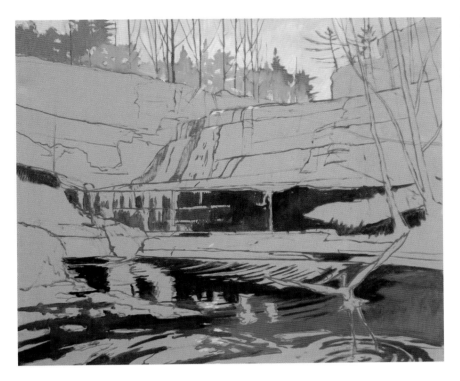

2 Lay in the lightest and darkest areas

Begin painting the lights in the sky while carving out the silhouettes of the trees. For these light colors in the sky, use Cadmium Yellow Lemon, Hansa Yellow, Cadmium Orange and white. For the trees at the ridge crest, use Cadmium Red Light, Burnt Sienna, Venetian Red and Cadmium Orange.

Then start laying in the darker values in the water, using Burnt Umber mixed with Phthalo Green and Burnt Sienna.

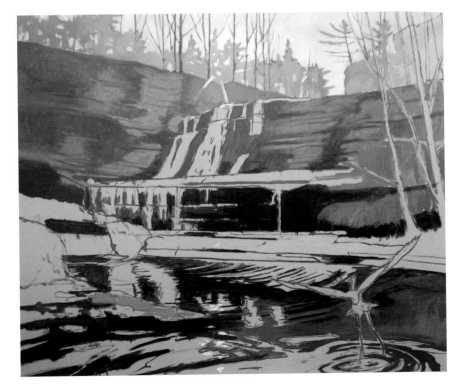

3 Midtones next

Start working in the midtones and the darks of the gorge walls, using Yellow Ochre, Chromium Oxide Green and Burnt Umber. In the water in the foreground, increase the warmth by using more Venetian Red and Burnt Sienna.

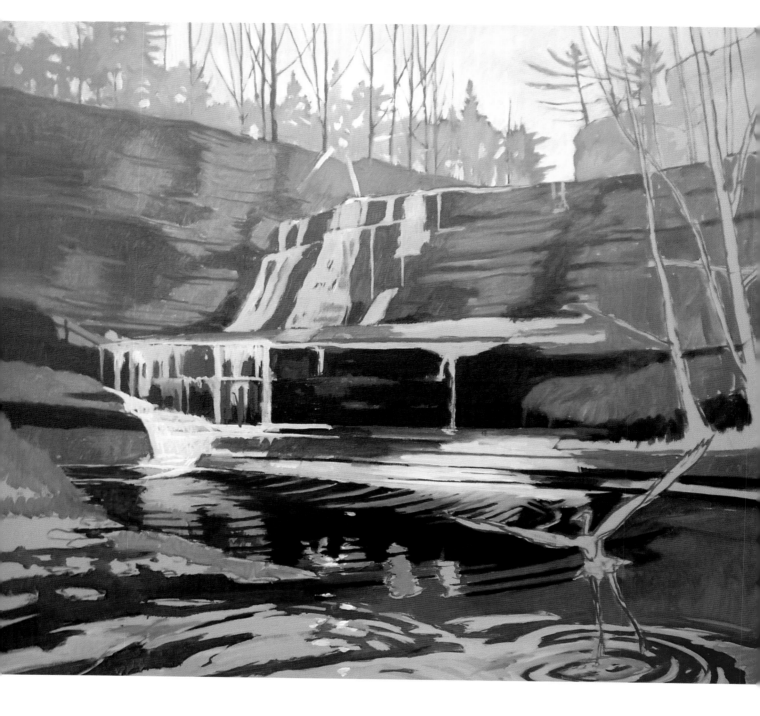

4 Develop the water and the darks

Begin developing the waterfall—in this case, using a warm gray. For the water that is reflecting the waterfall, keep the temperature cooler while making the value darker as well. For this area of reflection, use white with Ultramarine Blue and some Phthalo Green with white. For the waterfall itself, use warmer grays throughout, especially as the water nears the top close to the sun. These warmer grays are achieved with white mixed with Yellow Ochre and a just a tad of Ultramarine Blue. Push the darks darker throughout the painting.

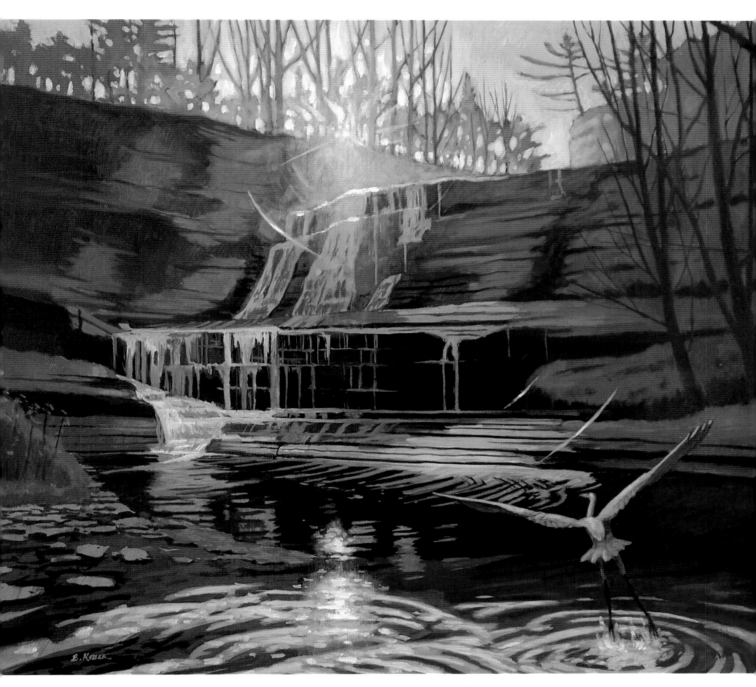

Autumnal Ascent—Frontenac
Oil on linen. 26" × 30" (66cm × 76cm)
Collection of Bojan Petek, Croton-on-Hudson, NY

5 Add glazes of light

In this final stage, there are several layers of glazed light applied in and around the sun and on the coruscating glint on the rippled water in the foreground. The glaze is applied in thin layers with minimal amount of pigment to create a transparent veil of light. The colors in these glazes include small amounts of Naples Yellow and Hansa Yellow with white mixed into Utrecht glazing medium.

The values are going increasingly lighter as they near the top of the waterfall and closer to the sun. The darker, intense blacks of the water create more contrast with the heron in the foreground; that and the heron's sharper edges move the bird closer to the viewer. This composition was developed to lead the viewer through a kind of zigzag starting at the lower left, then moving back and forth while stepping up the layers of rock and out the gap in the trees, to return to the sun and back in again.

Vineyard Sunset: Glazing for Luminosity

Although I seldom use glazes, I decided that this work would benefit from glazing to assist in creating the glow of late summer warmth and atmosphere. I also wanted to use layers of transparent paint, which would allow aspects of each underlying color to show through somewhat and create a nuance of various tones and hues.

The use of glazing medium also accelerates the drying time, so oil paint begins to have the advantages of fusing and blending but also approaches the advantages of fast-drying acrylic as well. One of the advantages is that the paint sets up quicker to allow subsequent layers or even thicker impasto applications during the same day of painting or veils of glaze on the following days.

MATERIALS

SURFACE | Stretched medium-weave linen, 38" × 44" (97cm × 112cm)

PAINT COLORS | Burnt Umber • Cadmium Orange • Cadmium Red Light (or Cadmium Scarlet) • Cadmium Yellow Deep • Cerulean Blue • Cobalt Blue • Hansa Yellow • Naples Yellow • Permanent Rose • Phthalo Green • Ultramarine Blue • White • Yellow Ochre

OTHER | Raw Sienna acrylic paint • Clove oil • Glazing medium (Utrecht)

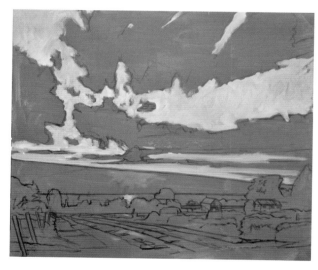

1 Organize the shapes and create a path

First, tint the surface with a layer of Raw Sienna acrylic paint thinned with water. This color was chosen for its warmth, which will be allowed to influence the subsequent color application, through the glazing process and also as parts of it remain exposed at the finish.

Begin your drawing using Burnt Umber with a small amount of clove oil added (to slow the drying time, only in the drawing stage), while paying attention to the overall distribution of shapes and their interaction. Organize the clouds into layers that make up the largest area of the image, remembering the eye level and perspective. A zigzag leads the eye, initially following the grassy area between the vineyards.

2 Carve out the clouds

Begin carving out the general silhouette of the cloud shapes. This process keeps the overall figure/ground relationship (light to dark arrangement) simplified and clear. In this case the clouds are defined as dark shapes against the light of the sky. This will change and modulate some as the painting progresses. Start by painting the sky at the top using Cobalt Blue and Ultramarine Blue with white and a small amount of Naples Yellow mixed in for warmth. As the sky approaches the horizon, eliminate the blue hues and use just the warm colors of Yellow Ochre, Naples Yellow and white. As the sky stretches out to the north or to the right, mix in a small amount of Permanent Rose for a touch of pink. This is further brought out in subsequent stages.

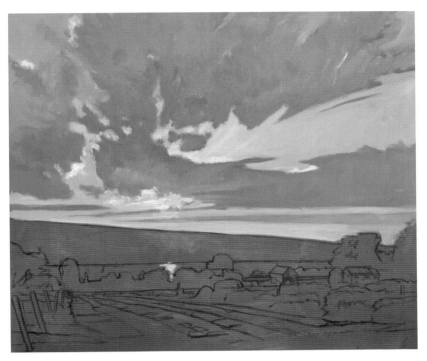

3 Fill in the clouds and warm up the sky

Add warmer hues of Cerulean Blue and Naples Yellow into the sky mixture at the top along with white. Begin to paint the clouds, using warm colors even in the gray to unify the warmth. Paint them with a mixture of Yellow Ochre, Naples Yellow, Burnt Umber and Ultramarine Blue with white. Adjusting the levels of these colors to create a warm-hued cloud can be very challenging. The goal is to create an airy effect with gray color that is warm but not muddy. As the cloud nears the sun, add more warm, light tones, including Hansa Yellow, Cadmium Yellow Deep, Naples Yellow and white. Minimal amounts of the warm yellows will go a long way to create intensity in certain areas without overstating the chroma throughout.

At this point we have not used any glazing in the painting.

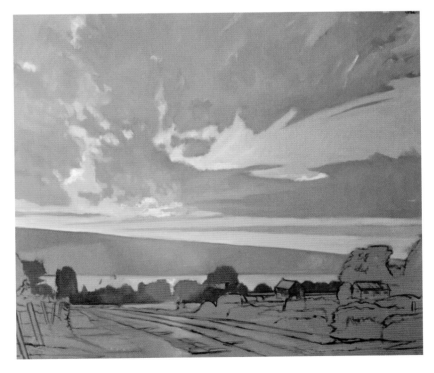

4 Begin glazing

Make the first statement of the trees in the midground by applying fairly chromatic (intense) warm hues to suggest the sun bleeding through. Apply a first layer of glazing in the foreground and in the trees, with a coat of golden color (comprised of varying degrees of Yellow Ochre, Cadmium Orange and Cadmium Red Light or Cadmium Scarlet) thinned with glazing medium. In the sky and mountain, increase the golden color around the sun with glazed warm tones.

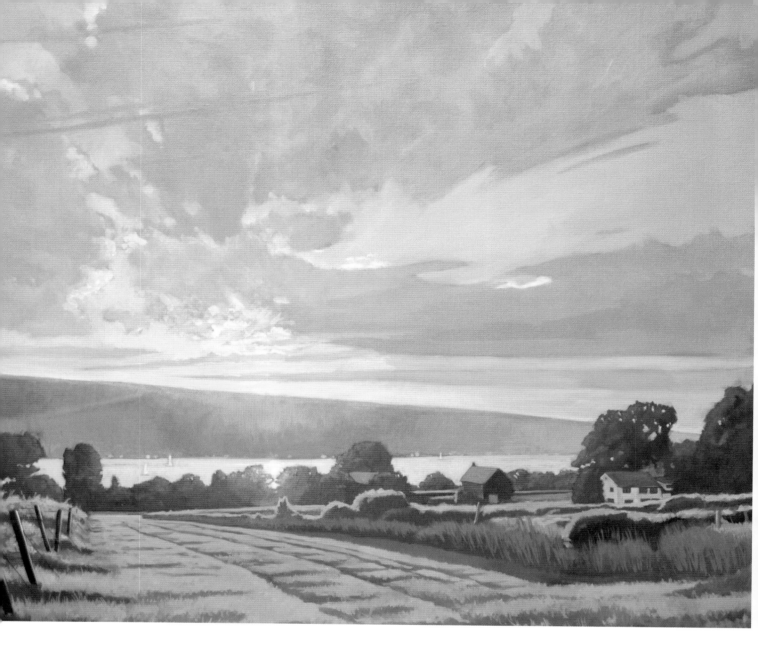

5 Soften the scene with more glazes

Now a more concerted glazing process begins. Use glazing medium to thin out the paint and to assist in smoothing and softening edges. To develop the light on the distant mountain and the color in the trees in front of the lake and in the clouds, apply several layers of thin, semitransparent color. I am using some fairly intense, warm hues here, Cadmium Orange and Hansa Yellow, along with the more subtle Naples Yellow with white. Render the clouds more airy and atmospheric by lightening them and softening the edges while articulating some of the subtle layers and shapes. Also add another layer of lighter but muted blue to the sky using the glaze, which also helps to soften the edges between the sky and clouds. The upper areas of the clouds have some areas of slightly darker patches that were achieved by going slightly cooler, using Ultramarine Blue and Burnt Umber with white. The purpose of adding Burnt Umber into the combination for these grays is to mitigate or lessen the coolness of the Ultramarine Blue. I am after a more neutral gray here. Sometimes, I get the same neutral gray by combining Phthalo Green and Permanent Rose (near opposites, to cancel each other) with white.

In the foreground and midground areas, begin to develop the details and articulate the topography in colors of your choice. Keep the light direction in mind, as the light will describe the shape of the gradually sloping hill and the horizontal furrows in the grass. The vines are catching the light too, as the sun illuminates them from behind.

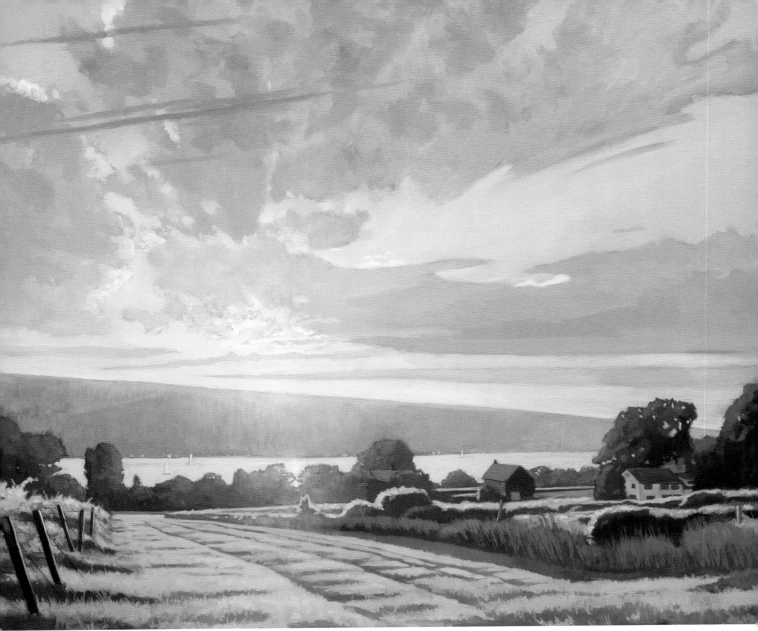

July Evening Light—Seneca Lake, Burdett, NY
Oil on linen. 38" × 44" (97cm × 112cm)

6 Refine the colors and details

The overall color scheme of this painting is predominantly warm, with a limited palette. The light effects are created by subtle contrast of value within the selected range of this warm palette. Further soften and lighten select areas—such as the glow on the mountain below the sun and the reduced value contrast in the vines in front of where the sun is coming through the trees from the lake—by using a layer of mostly Yellow Ochre and perhaps some Naples Yellow. Add warm lights in the trees to softly articulate roundness while showing light direction. Some of the intensity may need to be toned down; for example, in the ray of light on the left, the orangish color was lightened and pushed toward a light ochre (Naples Yellow— being the low-chroma color—mixed with white).

Finally, apply another layer of the glazing medium to unify the level of gloss. This final glaze is often required more so in paintings that use Burnt Umber and other colors that frequently dry with a dull or matte quality. The Utrecht and Liquin brands of glazing medium are very similar and impart a sheen or luster that is more like satin rather than high gloss.

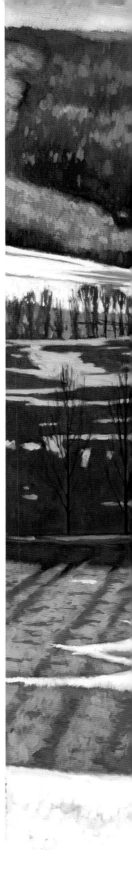

expressing through composition & format

The emphasis of this chapter is on approaching composition through an awareness of borders and the relationships within. Taking the format (or overall shape) of a painting into consideration is an essential preliminary step to creating effective compositions. We will also examine various structural design plans for paintings. Becoming acquainted with some of these basic approaches to organizing the flow and key elements of a painting, we will arrive at a better understanding of compositional harmony and how to accomplish it in our artwork.

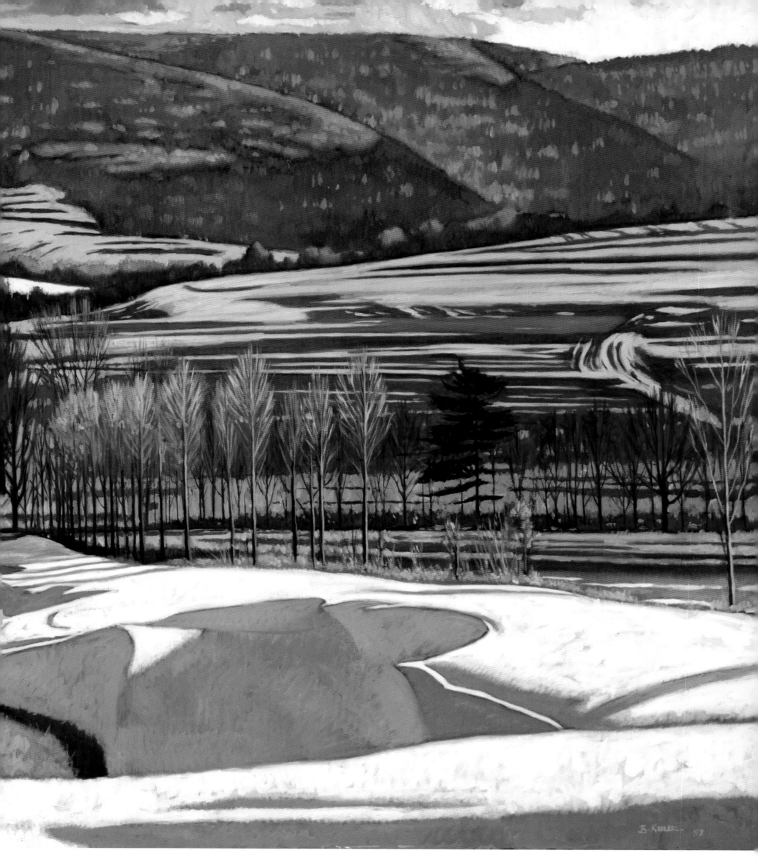

April Thaw—Valley Near Mehoopany, PA
Oil on linen. 54" × 60" (137cm × 152cm)
Courtesy of West End Gallery, Corning, NY

On this particular morning, the past weekend's big snow had already started to melt and huge drifts were carved out in high relief. I painted a small oil down in this valley, next to a little stream that was running fresh with snowmelt. This view of the valley presents only the land, without the farms.

Exploring Format Possibilities

When we first begin to consider our subject and how we will portray it, it is crucial to take into account the shape or format of the canvas or surface. Just carrying any canvas out of the art store and accepting its format as a given without taking into account your goals for the particular painting will undermine your work.

Trying a variety of formats reveals the potential in any given scene. This is why I like to experiment with sizes that are not "standard," or the traditional prestretched sizes. By selecting a variety of formats to explore a given scene, it will show that by merely considering the confines of our picture space, we will add a new sense of order and structure to our work.

Additionally, in our quest to appreciate the dynamics of composition, we need to consider the four most important lines in any work: the four borders or outside edges that define it, and the resulting shape or format. Why is it so important to consider the boundaries of our painting surface? Because some artists regard the edges to be indispensable as a means to gauge relationships and interaction within a composition. Secondly, I think it is necessary to "honor the center" of the work, which means to recognize it (often with a mark of some kind) in order to access and gauge all the rest of the major and minor spatial divisions.

I often use the "movable borders" or "forgiving method" of sketching, the idea being to allow for improvement in the composition by extending the format if needed. For me, the first purpose of a preliminary sketch is to arrive at an effective distribution of shapes. and if we just draw on a sketch pad without first making borders, it is nearly impossible to adequately "honor the center" and therefore make meaningful decisions about the overall relationships and intervals. Value relationships, details, modeling and articulation of form all come later, after the foundation and armature is established.

Getting all the elements of a painting to work harmoniously is the goal of creating dynamic designs, and purposively working with varied formats is one way to foster and develop our design skills.

Venice Sheets
Oil on canvas on panel.
18" × 20" (46cm × 51cm)
Collection of Ed and Wanda McNamara,
New Cumberland, PA

Nearly square
In this view of a street near the Giardino, a district in Venice, warm late-afternoon sunlight streams through a cascade of laundry hanging between the buildings. I like this off-square format for the tension created by the difference in dimensions, and also because the elongated square is not quite perceived as a rectangle but is easier to compose within than a true square. The sheets, shown in diagonal and horizontal overlapping layers, all lead down and toward the end of the street. The sunlight is coming back toward us in the opposite direction, casting shadows and filtering through the towels and sheets.

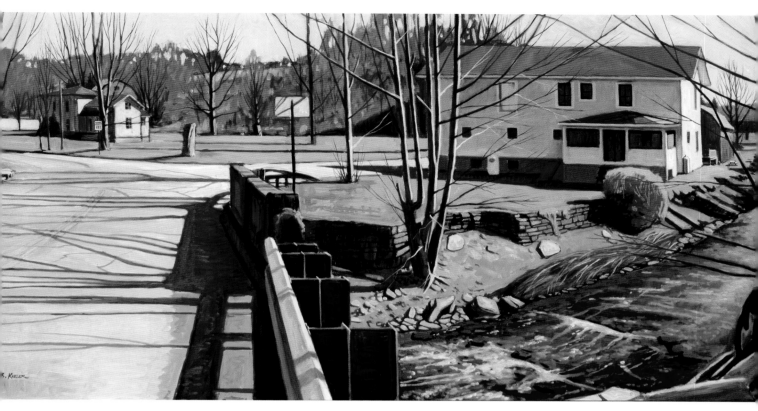

Early April—Hollenback, PA
Oil on panel. 24" × 48" (61cm × 122cm)
Collection of Terry and Barb Keeney,
Sugar Run, PA

Elongated horizontal allows for more inclusion
This little community has a classic timelessness to it, as if it were still 1930. Many such small towns had schools, stores, churches and everything else needed for basic living. This section of Sugar Run Creek, called the Panther Lick, is a popular spot for spring trout fishing, so I could imagine the trout in its cold, clear waters. This elongated horizontal format allowed me to include more than a standard-size canvas would. The road leads the viewer in from the lower left and then guides the eye around in a wide oval and back down the stream, after pausing to appreciate the buildings. The light streaming across the road with heightened color continues the movement of the stream.

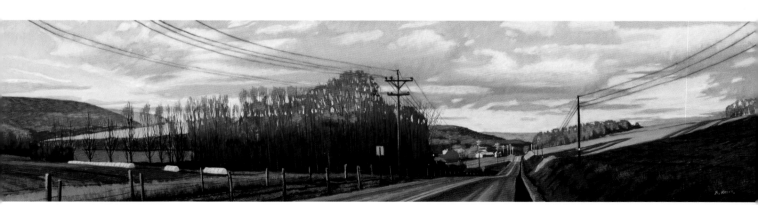

Last Light of a Winter Day—Road From New Albany, PA
Oil on panel. 10" × 36" (25cm × 91cm)
Collection of Steve and Marie Fitzsimmons,
Wyalusing, PA

Extreme horizontal for a panoramic view
This road between Wyalusing and New Albany in Pennsylvania rolls over beautiful hills and past many delightful views. The road leads us into this panoramic image and is bolstered by the telephone lines. The cluster of buildings, house and barn to the left of the road serve as a focal point. The late afternoon light is restricted to just certain areas, and the light describes the terrain as it flows over and around the earth and trees. I love the way color is heightened at the end of the day, lending a rust-like hue to the treetops.

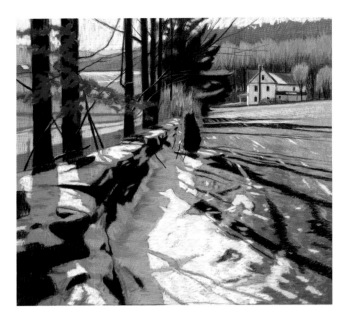

January Afternoon—Oak Hills, PA
Pastel on paper. 30" × 36" (76cm × 91cm)

Adjustments and opportunities

Often I recreate the same view in various mediums just to explore its potential—in this case, the view along an old stone wall on a warm winter day. The red oak leaves add a nice note of color to the foreground. The off-square format was organized here by pushing the stone wall and trees far to the left, which in turn brings out the play of light on the large expanse of the field. Using areas of open space is an effective tool for strengthening compositions. The feeling of light on melting snow gives us that appreciation and anticipation of spring.

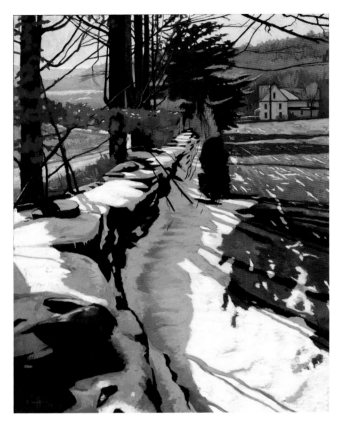

Oak Hills Stone Wall, Melting Snow
Oil on linen. 54" × 30" (137cm × 76cm)
Collection of Paula Bainbridge and Eric Gregorie, Athens, PA

Shifting the focus

This elongated vertical format brings the old wall into prominence more, giving the viewer a chance to appreciate the labor and craft of building these stone borders.

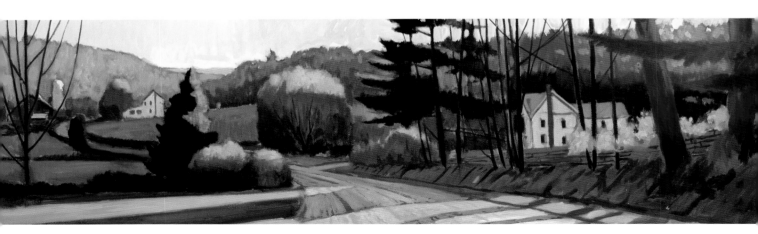

May Evening—Oak Hills, PA
Oil on panel. 10" × 36" (25cm × 91cm)
Collection of Jeanne and Don Jackson, Haddonfield, NJ

A wider view

An elongated horizontal format allows us to include more of the scene. In this painting, the season was also different than in the other two works on this page, and the vantage point changed to the other side of the wall and road. This format and vantage point allows for multiple points of interest: the sun, filtering light, cast shadows and distant buildings.

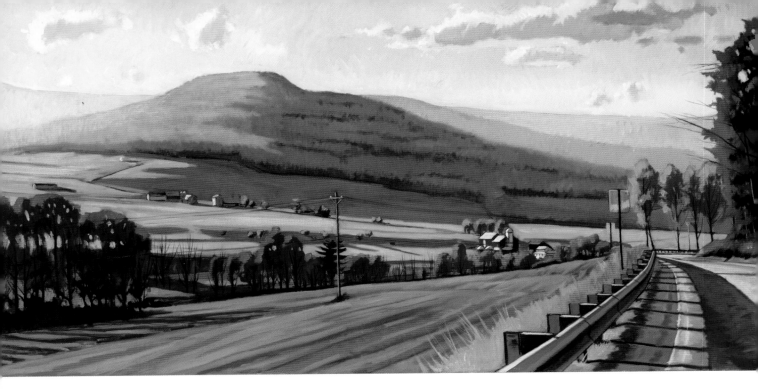

**Autumn Valley Scene,
near Mehoopany, PA**
Oil on linen. 30" × 60" (76cm × 152cm)

Choosing the format that best sets the scene
This beautiful valley stretches between two mountains, presenting many intriguing views. The horizontal format of this painting accentuates the panoramic or wide-open space of the scene depicted. The light coming from the left is accentuated as it flows over the mountains and describes the topography of the valley.

July Clouds, Mehoopany, PA
Oil on linen. 18" × 20" (46cm × 51cm)

Looking skyward
This painting explores the same valley as the painting above, but from a different angle and using another format. This off-square format, with the cluster of farm buildings placed low in the composition, emphasizes the dominant sky and open atmosphere. The relatively small area of man-made structures (the buildings) contrasts with the wide expanse of nature (the sky), making this work a study in opposites.

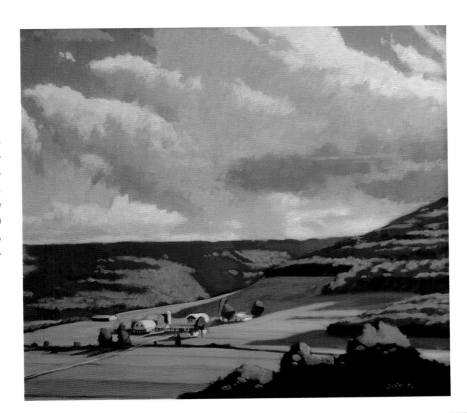

Composition Strategies for Creating Dynamic Movement

Creating a sense of flow through your work and orchestrating the sequence of events or main players in a painting is one of the fundamental building blocks of mastering composition and should be considered before any details. It is also one of the most rewarding processes of picture making, as it entails a dialogue or working relationship where you, as the artist, enter into a role not unlike that of a director of a play or the author of a novel. You are assuming an active and creative role, rather than a servile one of merely transcribing the given visual information.

There are many strategies to consider to create a flow and rhythm in and around your compositions. Pondering the relationships of the main elements of your work and how they are working together is also vital, as is the organization of intervals. Intervals are really the key to effective composition, and as in music, the cadence or rhythm and flow followed by the viewer through our arrangements is how the overall beauty, and even musicality, of a work is obtained.

The following sketches present simplified design concepts, each an effective method of creating a flow into and around the picture surface and within the illusionary space. Each is asymmetrical, which means that the center of interest is positioned away from the center of the design. Each also aims to create a harmonious relationship between the major shapes and elements of a painting.

The art of painting

You may approach painting as just mere reporting, a process of rather servile duplication. But when we begin to select our vantage points judiciously, we can find spots to paint that start out with potential, and then further arrange, alter or fine-tune as the concept leads to more elaborate studio versions. When you begin to consider painting in these terms, it becomes an act that brings out the "art" or inherent beauty in the painting process.

"S" or serpentine

The "S" or serpentine design imparts a natural flow that leads the viewer's eye in and around the image and back into space. The "S" design can allow the painter to create a rhythm or bring out the natural rhythm of almost any scene, and to arrange elements to lead the viewer to certain areas.

"Z" or zigzag

This plan is less subtle than the "S" design, but more dynamic due to the angular and sudden changes. The "Z" or zigzag method of composing has great potential for directing the viewer in a dynamic journey. When placing key objects within an image, they can be located at the change-of-direction points.

"O" or circle

The circle in this design is placed off-center, making the plan asymmetrical, and then the main elements of the painting are placed around the circle.

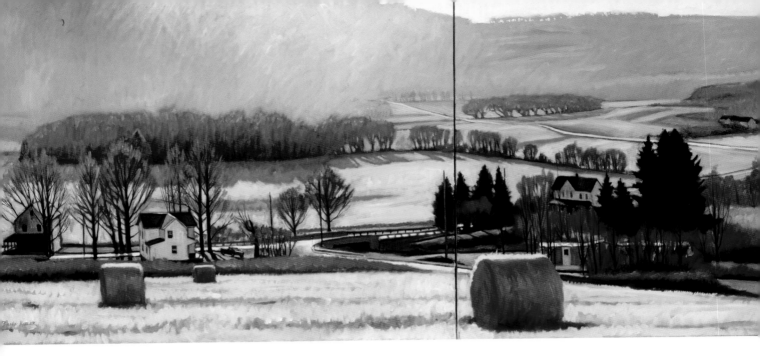

Winter Solstice Landscape—Colley, PA
Oil on canvas. 30" × 64" (76cm × 163cm) diptych

Zigzagging into a scene
This zigzag composition was carried out as planned in the sketch. You can see that I was planning to do a diptych (or two-panel painting) early on in the conception of the work. The diptych format was used in the oil to take the sketch process into the final stage and make it an inherent part of the finish. When using the "movable borders" or "forgiving method" of sketching, the idea is to allow for improvement in the composition by extending the format if needed. So, in the oil shown, I just continued what I began in the sketch.

Summer Mist—Colley, PA
Oil on panel. 14" × 16" (36cm × 41cm)

Circular movement
In this small oil, there is an offset circular design at work. Although rather understated, there is somewhat of a circular containment formed by the bottom of the bales, then up and around and redirected back down through the curving vapor on the upper right. This circular method comes into use best when there is a naturally occurring arch or circle, such as the bend of tree branch, the arch of a bridge, a doorway or even a rainbow.

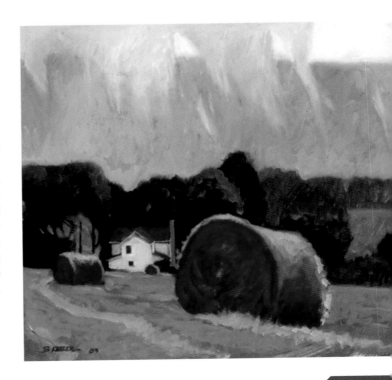

Radiating lines
Radiating lines in fields and other elements in nature can be used to direct the eye to a desired focal point.

Perspective lines
This design is similar to radiating lines but uses man-made structures such as roads to lead the eye to a key spot. These lines of perspective are called *orthogonals*.

Overlapping
Overlapping is a method particularly effective for achieving depth and recession of space. In this case, circular bales of hay are overlapped, leading the eye into the scene.

Triangle or pyramid
In this design, the main elements are arranged in a triangular presentation. Notice that the triangle is off-center and tilted for dynamic effect.

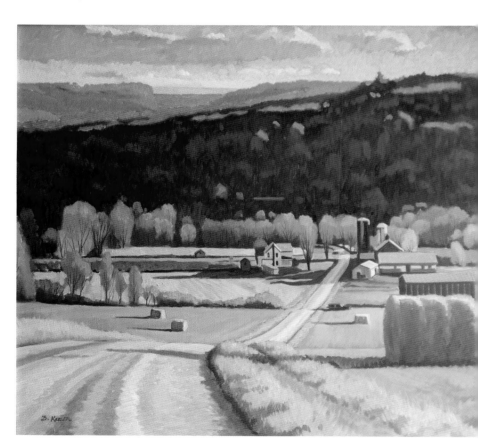

Edinger Hill October
Oil on panel. 26" × 30" (66cm × 76cm)

Creating a sense of space
The road and positioning of the bales are working together to augment the illusion of space. The foreground bale overlapping the outbuilding and the difference in the size of the bales all adds to the perspective and recession into space.

Edinger Hill Study
Oil on panel. 10" × 30" (25cm × 76cm)

Encouraging the eye to linger

This was painted from the tailgate of my truck on a relatively warm January, as the full moon was rising. These elongated horizontal formats are similar to a frieze in ancient statuary, like groups of marble figures atop the Parthenon, in how they are organized. The similarity is that one reads across the image, while lingering for details and main points of interest. In this painting, the road leads us in, but the final light is catching just the top of the house and trees, and finally moving over to the rising moon. The house becomes the main focus, with the moon and the point where the road ends atop the hill forming other points of interest—all three forming a type of interior triangle.

Townscape, Nicholson, PA
Oil on linen. 52" × 54" (132cm × 137cm)
Collection of Patsel's Restaurant, Dalton, PA

Overlapping to step the viewer into a scene

The massive viaduct dominates this view of a small town. The two other smaller bridges are also interesting supporting elements. The roofs of the nineteenth-century houses were overlapping from this angle, which assisted in creating a visual progression into the work.

Doorway or portal (natural)
This simplified landscape sketch shows how using trees to form a door or window can form an effective framing device to lead the eye into the image.

Doorway or portal (man-made)
This thumbnail cityscape sketch is based on the Tiber River in Rome. Using bridge arches, as I have done here, or other architectural forms can also act as a doorway or portal into the image.

Cruciform (natural)
This simplified sketch illustrates the idea of organizing the painting's main components into a broad cross or cruciform shape. In this case, the cruciform is formed by natural elements in a riverscape.

Cruciform (natural/man-made)
This thumbnail sketch of a stone wall in a landscape has been organized so the scene's main elements (both natural and man-made) fall into a generalized cross or cruciform shape.

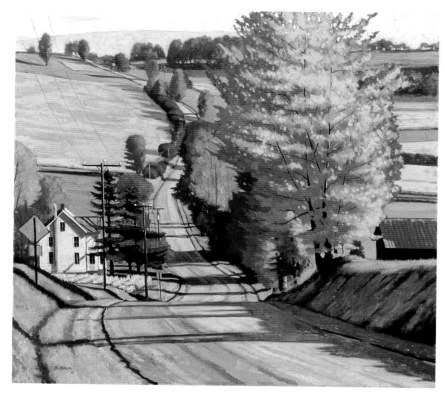

Autumn Road—Spring Hill, PA
Oil on canvas. 36" × 40" (91cm × 102cm)
Private collection, NJ

Combining design strategies
I love the swoop of this landscape as the road leads down through the dip and up the other side. This painting utilizes a hybrid type of composition. It combines some elements of the "S" design, as the road winds into and over the landscape, and at the same time the road divides the format in an asymmetrical way (offset to the left), making a type of cruciform arrangement as well.

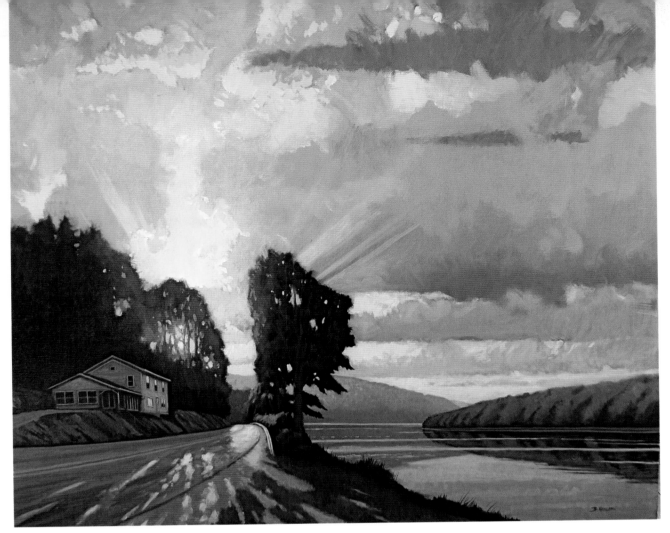

Luminous Landscape
Oil on linen. 42" × 46" (107cm × 117cm)

"X" design
The center of the "X"—where the focal point will go—is dynamically placed off-center. This sketch illustrates the main armature of the next landscape sketch.

"X" marks the spot
The sky dominates in this sunset scene. A large area of clouds serves to draw attention to the featured performers—the cluster of sun, house, road and dappled light—which are positioned off-center to the lower left, at the center of the "X." This focal area is also where the darkest and lightest tones of the painting reside.

Ensuring Dynamic Points of Interest

There are some easy ways to ensure good placement of dynamic points of interest in your painting. They will help you avoid placing the key elements of your scene in a static position or directly in the center of the canvas. However, we don't have to stubbornly insist that our compositions always land everything in dynamic points. The idea, though, is to become acquainted with basic design elements of harmony and spatial distribution. Once we know the rules, we can more effectively break them or play with them.

The diamond-and-"X" method
In this method of plotting dynamic points, simply make a diamond on your canvas and then an "X" from the corners. The points of intersection on the sides of the diamond are the best places to put key elements. This method applies whether the format is a rectangle or a square.

The rule of thirds
In this method, simply divide your canvas into thirds, as if it were a tic-tac-toe board. The intersections are dynamic places to locate key elements. This method can be applied regardless of the shape of your canvas.

Variation in intervals
Composing with attention to intervals—the spaces between objects and shapes—will also help you dynamically place the elements of your painting. Rather than a symmetrical design with all the objects evenly spaced—resulting in a predictable, boring arrangement—alter the intervals, as I did with these houses, clouds and mountains.

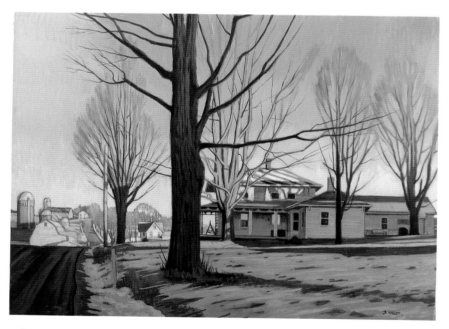

Winter Morning Light—Clapper Hill, PA
Oil on linen. 30" × 40" (76cm × 102cm)

A low eye level for a dynamic division of space
In this scene, I was attracted to the warm light streaking horizontally across the lawn and buildings. The eye level is purposefully set quite low on the canvas to set up an inherently dynamic division of space. The primary vertical is the large, dark tree in the foreground, but the next tree to the left augments this division. The juncture of the horizontal streak of light and the secondary tree is located at a dynamic point.

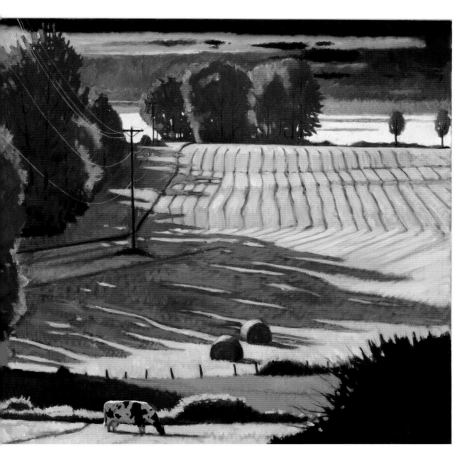

October Landscape With One Cow
Oil on canvas. 36" × 40" (91cm × 102cm)

Creating a dynamic flow
In this work there is nothing precisely positioned at any dynamic point. However, the flow of the work implies these areas and sort of dances through the various "sweet zones." We enter at the bottom left with the cow in a foreground theatrical stage, as it were, then over the dark boundary into the secondary stage. Then we follow the play of light and shadow past the bales and up the mowing lines of the hillside to exit near where the upper dynamic point would be, at the crest of the hill. We "honor the center" here by having the flow come close to the center on the way up, but not actually go through the center. In general, it is best to avoid making dynamic lines cross in the center, as we want to encourage the asymmetry and dynamic distribution of major shapes and flow of energy.

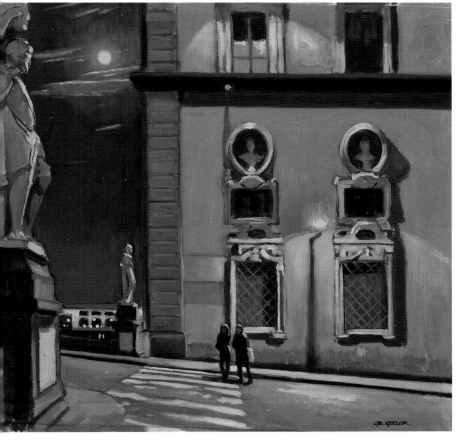

Florentine Full Moon Walk
Oil on linen on panel. 18" × 20" (46cm × 51cm)

A meeting in the "sweet zone"
This painting was done while visiting Italy during the winter, after being inspired by the night ambience of Florence. In this cityscape, the figures form a focal point near the lower center, but the locus of main elements occurs at the vertical line formed by the division between the building and the night sky and the implied eye level situated about a quarter of the way up from the bottom, near the base of the far statue. This vertical-horizontal juncture is at a dynamic point. The famous Ponte Vecchio bridge in the far distance is also located in the lower left and is a part of this cluster of lines and objects sharing the "sweet zone."

Rocky Landscape: Composing in a Square Format

If you've always painted on a standard rectangular canvas, expand your expressive potential and ability to orchestrate and compose your work by selecting new formats that are specific to your subject. In his book *The Power of Limits*, architect György Doczi suggests that we can think of the format as our empowering structure. To start, we need to experiment and become familiar with acknowledging the format and working with it. Then, after experimenting, when we return to more conventional sizes, we will have a greater appreciation for and be more effective in arranging our compositional elements.

The goal of this demonstration is to express the quality of morning light using a limited palette within a square format. Oftentimes we can represent the beauty of light with a minimum of colors or with colors chosen to augment a certain quality. In this autumn scene, we will focus on the warm colors of changing foliage.

MATERIALS

SURFACE: Stretched fine-weave, oil-primed linen, 40" × 40" (102cm × 102cm)

PAINT COLORS: Black • Burnt Umber • Cadmium Orange • Cadmium Red Light • Cadmium Yellow Light • Chromium Oxide Green • Naples Yellow • Raw Sienna • Ultramarine Blue • Venetian Red • White • Yellow Ochre

OTHER: Glazing medium (Utrecht or Liquin) or mineral spirits

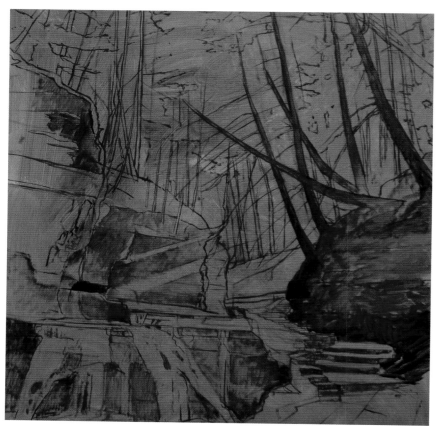

1 Make the initial sketch

Start by tinting the surface with Raw Sienna. The color scheme in this work will be predominantly warm, therefore the tint of the canvas will have an important effect on the final look of the painting. Then make your drawing using a dark brown. The eye level has been set fairly low, just above the waterfall, with the rocks and stairways all drawn in perspective.

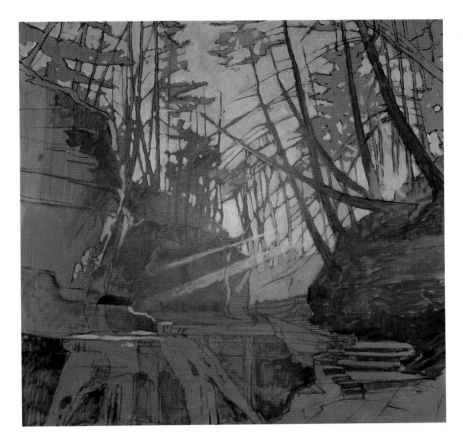

2 Lay in a warm sky

Carve out the shapes of the trees by painting the light sky behind them. Use white combined with Naples Yellow to give the sky warmth.

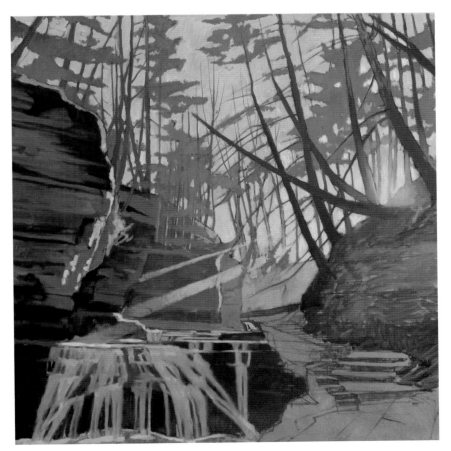

3 Develop the midtones

Begin working into the midtones—which in this case are the areas of trees and rocks—using Yellow Ochre, Chromium Oxide Green, Cadmium Orange and white. Work fairly broadly and treat the shapes graphically and rather flatly—in other words, don't articulate form too much at this point.

Begin the waterfall with a mixture of Ultramarine Blue, Burnt Umber and white to produce a gray color that can be further lightened later. The glow of the sun is being painted at this stage by adding Cadmium Red Light, Naples Yellow and white to the area around the trees, while softening edges. Add the slanting beams of light using white and some Naples Yellow. I like Naples Yellow because of its low tinting strength, which warms and lightens but does not overpower.

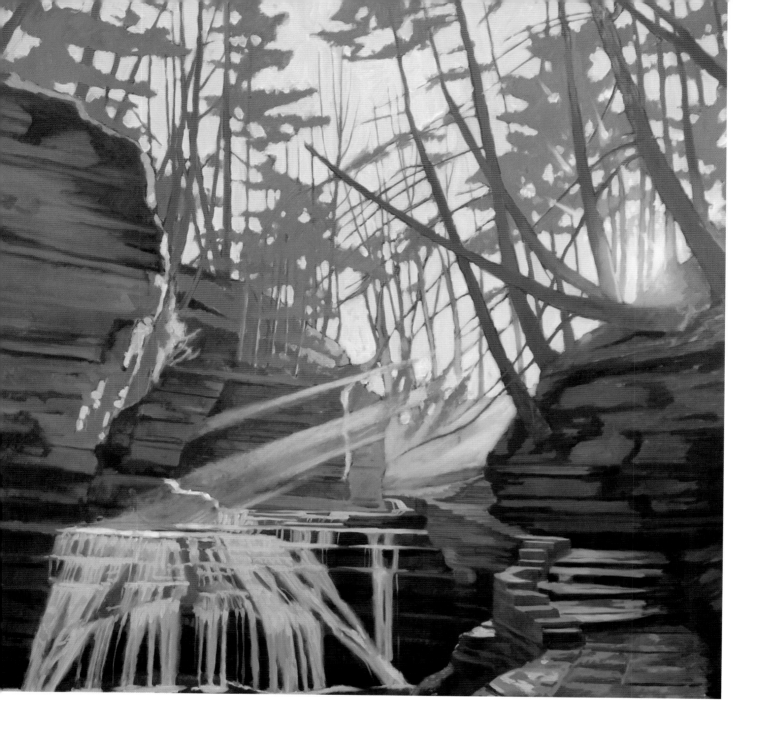

Deepen the values

4 Work on the stairs to the right and further develop the details throughout. Use Burnt Umber and black to push the contrast and deepen the values in the steps and around the waterfall. Work into the lighter areas of the rocks on the left with a mixture of Yellow Ochre, Burnt Umber and white to bring out the striated forms.

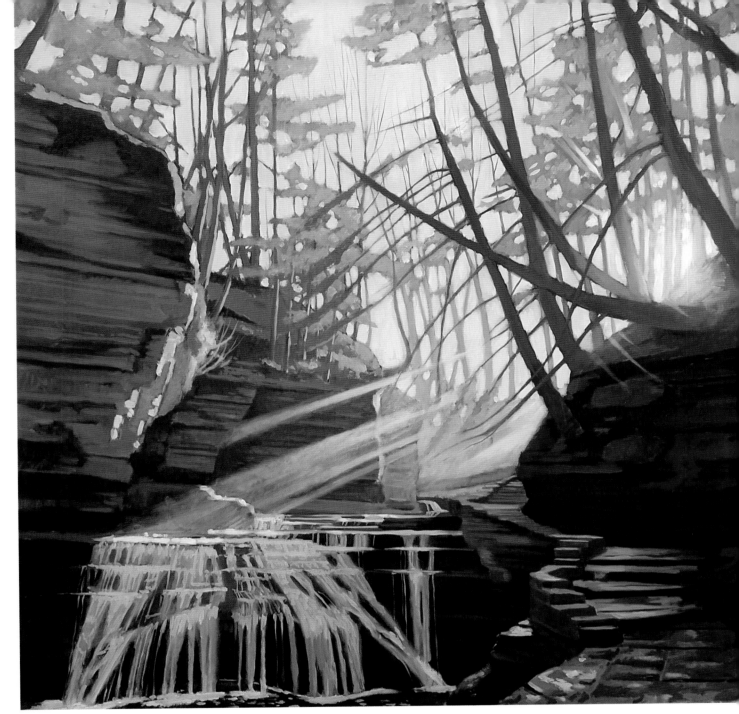

Buttermilk Morning Light
Oil on linen. 40" × 40" (102cm × 102cm)

5 Push the contrasts

Create two distinct areas of trees by separating them into "families" of values. The foreground trees are all darker than the background trees. To further this goal, soften the background by using a mixture of white and Naples Yellow thinned with either solvent (mineral spirits) or a glazing medium for the sky, and Cadmium Yellow Light for the trees. In this way, both areas are wet, and a large, soft brush dragging color lightly will soften and blend the edges. To create depth, soften edges and decrease the value contrast in the background, then do the reverse in the foreground. Darken the foreground rocks on the right and unify their values to take away contrast between individual rocks while increasing the overall area's darkness. Go over the lights to punch up their brilliance. Use Cadmium Red Light and Venetian Red to increase the chroma around the sun.

Neighborhood Street: Taking a Wider View

In this demonstration, we will attempt to convey backlighting in a townscape and show how light describes the location. We will also explore the importance of establishing strategically placed verticals and horizontals in this elongated rectangle format.

MATERIALS

SURFACE: Stretched medium-weave linen, 22" × 40" (56cm × 102cm)

PAINT COLORS: Alizarin Crimson • Burnt Sienna • Burnt Umber • Cadmium Yellow Light • Cerulean Blue • Cobalt Blue • Ultramarine Blue • White • Yellow Ochre

OTHER: Neutral Gray acrylic paint (Utrecht)

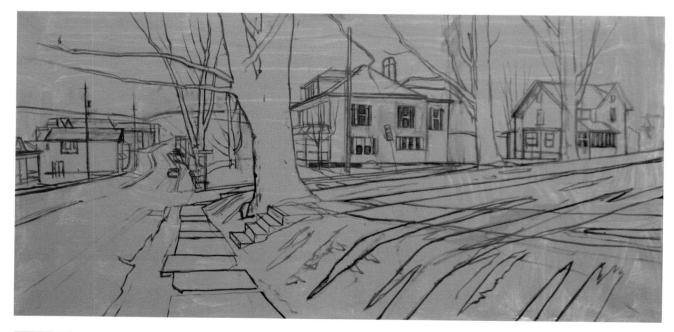

1 Pay attention to perspective and division of space

This scene attracted me for its timeless quality, as it looks in present day much like it did in 1910. Compositionally, I selected this view with the large tree and sidewalk to form an interesting arrangement and division of space. The largest tree divides the canvas into simplified large areas. On a surface tinted with Neutral Gray acrylic, begin sketching with a dark brown.

This painting includes several buildings that necessitate getting the perspective correct. If you look closely at the tree behind the street sign, you will see an "X," put there to indicate the eye level and vanishing point (the point where all the parallel lines of the picture appear to converge). Keep the vanishing point in mind as you draw, as it is important to have all the perspective lines in agreement.

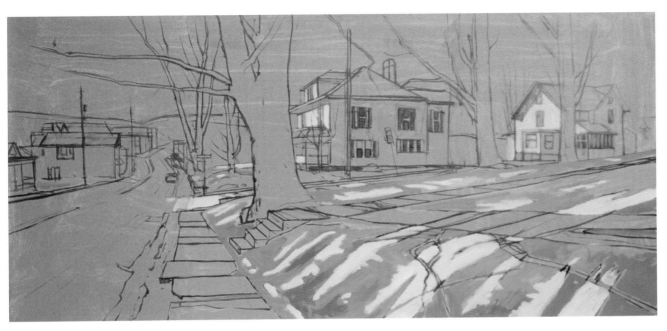

2 Block in the grass, snow and the sunlit sides of the houses

Begin by blocking in some of the lights in the grass areas, using Yellow Ochre and Burnt Sienna with white. The midtone tint of the canvas supplies the value for much of the surface, even though it will be painted over for the most part. Paint the snow and the sunlit sides of the houses using just white. The white at this stage is applied thinly and will eventually go even brighter with subsequent layers.

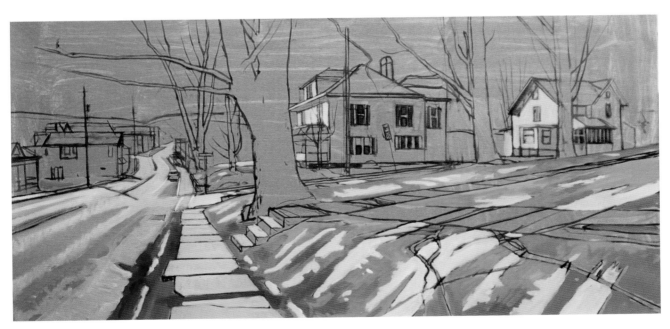

3 Introduce cool tones into the street and sidewalk

The street and sidewalk are cooler in tone. Apply a mixture of Ultramarine Blue with Alizarin Crimson and white for some parts, and Cerulean Blue along with Cobalt Blue and Burnt Umber with white for others. Continue developing the play of light on the surfaces, while articulating form and topography.

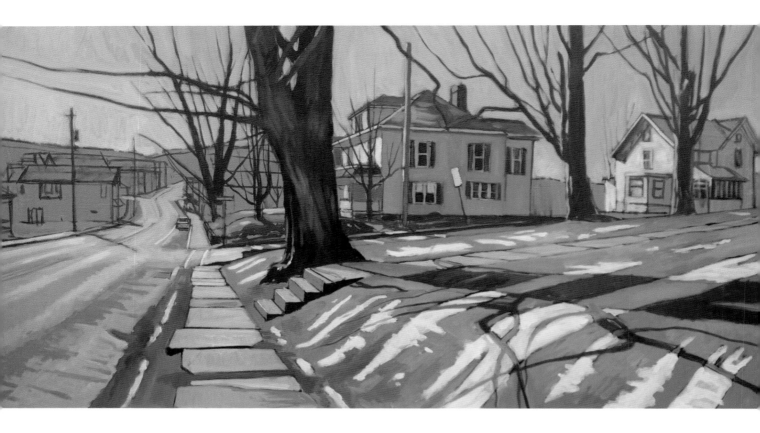

4 Compare how the shadows read as they develop

Work on the shadow areas throughout the painting and start to develop the details, bringing it all together gradually. For the trees, start with the largest limbs, waiting until close to the finish to add the smaller ones. The shadow area of the foreground tree is articulated with Yellow Ochre and Burnt Sienna to suggest lighter areas of the bark, and consequently the roundness of the tree trunk.

The central house was actually a yellow hue, so its shadowed areas were re-created with Yellow Ochre, Cadmium Yellow Light and white. The challenge here was to have the shadow area of the house read as shadow, even though the value is not that much darker than the sunlit areas of the grass.

White that dries just right

The white paint I prefer is Winsor & Newton's Griffin Alkyd. I use this fast-drying oil because it sets up the paint quicker, allowing for subsequent layering on the next day or even later on the same day. In this way, the oil painting technique combines the advantages of fast-drying acrylic while still retaining the ability to blend during the day of application, which is one of the appeals of oil paint and why it is generally admired among artists.

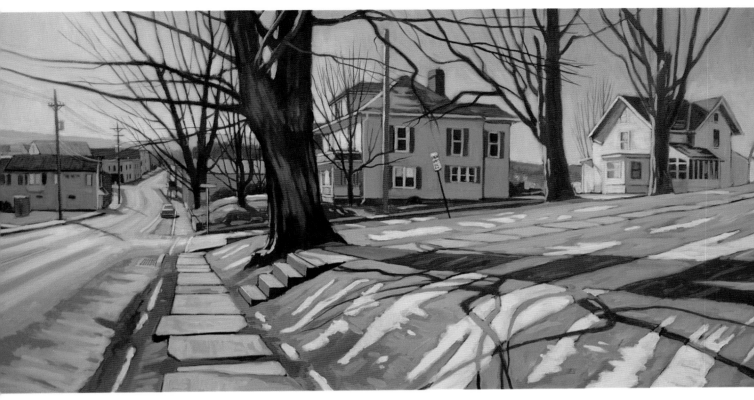

Taylor Avenue—Winter Morning Light
Oil on linen. 22" × 40" (56cm × 102cm)

5 Let the sunlight in

Further develop the buildings and details throughout the painting, softening or sharpening the edges as needed. Lighten and add warmth to the sky on the left, near where the sun is. Add deeper tones to the maple tree in the foreground, and punch up the warmth in the lighter areas of the bark in the same tree. Further lighten the sidewalk and the road, adjusting the application and direction of your brushstrokes to describe the flatness or roundness of the road. Though cooler than the grassy areas, keep the temperature of the grayish road and sidewalk relatively warm because of the sunlight affecting them.

Showing more than simply what you see

When composing, artists are also establishing a certain hierarchy of pattern and design. We attempt to find opportunities within nature to express concepts that will give significance and substance to an image, while avoiding a slavish, literal copying of nature. Many times a given scene seems to present little access to such a goal, but that is part of the search and the consequent reward. Rather than just accumulating one detail on top of another, we attempt to show that there is a plan and establish an order that lends a sense of direction to the process—and hopefully, a sense of coherence to the results.

Coastal Townscape: Guiding the Viewer's Eye

The coast of Maine in all its rugged beauty and with its wonderful nineteenth-century buildings is a splendid and compelling subject for artists. In this demonstration, we are depicting the small town of Stonington. The goal is to show a connection between the older man in the boat and the youth gazing at him, while portraying the beauty of the seaside buildings. Portraying the depth of the scene with the overlapping figures, and then having the scene recede into the distant shoreline, is part of the appeal and the challenge.

I did a plein air study (shown on page 82) of the same scene the summer before attempting this large oil.

MATERIALS

SURFACE: Stretched fine-weave, oil-primed linen, 40" × 40" (102cm × 102cm)

PAINT COLORS: Alizarin Crimson • Burnt Sienna • Burnt Umber • Cadmium Red Light • Cadmium Yellow • Cerulean Blue • Chromium Oxide Green • Cobalt Blue • Naples Yellow • Phthalo Green • Raw Sienna • Ultramarine Blue • White • Yellow Ochre

OTHER: Mineral spirits

1 Carefully indicate perspective and value as you draw

First, tint the surface with Raw Sienna thinned with mineral spirits. Then make your drawing, with some indication of value. The drawing is a crucial stage, as it sets up the overall composition that includes the key placements, such as the figures in the bottom right. Carefully mind the perspective created by the buildings, rocks and the water's surface as you draw.

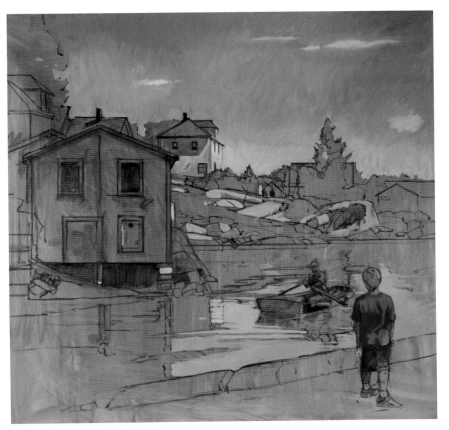

2 Start with the lights

Establish the overall value scheme by starting with the light sky behind the land and houses. For the sky and water, use various blues—Cobalt, Ultramarine and some Cerulean (mostly near the horizon), mixed with varying degrees of white, as shown in this step and the next.

For the rocks on the distant shore and the houses, use a warm white and gray, made with small amounts of Yellow Ochre, Naples Yellow, Burnt Umber and some Ultramarine Blue mixed with ample amounts of white. Also begin to carve out the light and dark patterns of the boy's shirt, using Cadmium Red Light with a bit of Cadmium Yellow and white in the sunlit area, and a cooler mix of Burnt Sienna, Cadmium Red Light and a little Alizarin Crimson in the shadows, applied thinly to allow the ground color to show through somewhat.

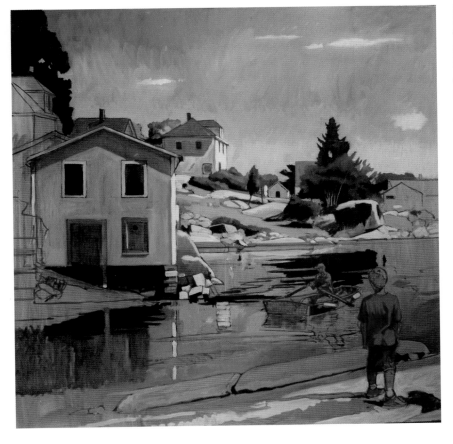

3 Lay in the buildings and the landscape

Apply thin layers of paint to establish the overall color of the buildings and the landscape. Paint the trees and shrubs in the background using Chromium Oxide Green, Yellow Ochre and Naples Yellow in the light areas, and Phthalo Green and Burnt Umber in the shadows.

Paint the sunlit part of the nearby house with the same mixture as the rocks: Yellow Ochre, Naples Yellow, Burnt Umber, Ultramarine Blue and white.

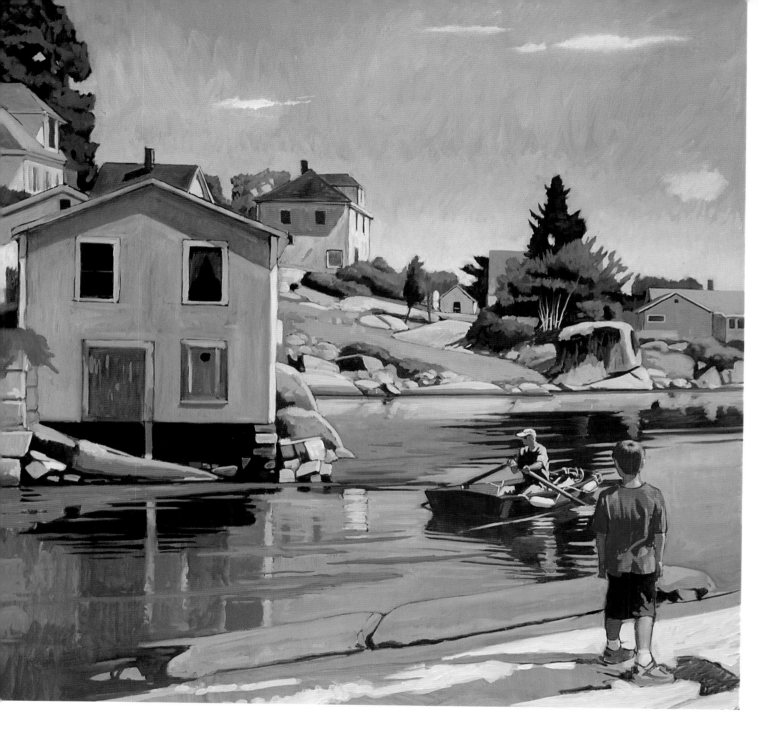

Bring the scene into focus

Work over all of the surface, trying to bring the entire image into focus gradually. Work on some of the details such as the man in the boat, the boy and the buildings. As you develop the water and its reflections, accentuate the warm, salmon-like color of the rocks and seaweed to augment how they describe the perspective layout and the plane of the water. These striated horizontal areas all serve to lead the eye back into space. They are brought out by virtue of the fact that their values are lighter than the water, but also by the color distinction of the warm against the cool of the blue water.

Stonington Row
Oil on linen. 40" × 40" (102cm × 102cm)

5 Go for detail, contrast and color

In the final painting stage, bring out more details, such as the cedar shakes in the building on the left. Further develop the contrast of light and dark as well as color. The sky color is pushed in chroma with a subsequent layer, using more Cobalt Blue and Ultramarine Blue at the top, and more Cerulean (a warmer blue) with white at the bottom. Increase the intensity of the boy's shirt by using more Cadmium Red Light in the sunlit areas, and pushing the darks by adding more Alizarin Crimson and Burnt Sienna. The Alizarin Crimson is a cool and transparent reddish color and works well for shadow areas of red. Whereas, the white and Cadmium Red Light are opaque and warm and work nicely to suggest the sun striking the shirt.

painting
skies, clouds & light

For centuries, painters have used the sky in their landscapes and cityscapes to add an ethereal aspect of swirling organic shapes dictated by the whims of the wind to contrast the man-made constructions and influences on the land. Some of the earliest and most notable examples are found in the seventeenth-century Dutch landscapes by artists such as Jacob van Ruisdael, who created vast and sometimes brooding and tragic moods through his depictions of skies. As the Dutch lowlands offered minimal variations in topography, those Dutch artists were forced to look upward for variation and drama. However, many of us have access to a great variety of contrasts in our land, so the sky is not needed as much for being the main actor in our painterly dramas, but as a supporting role to add to a choreographed dance with the land and towns depicted.

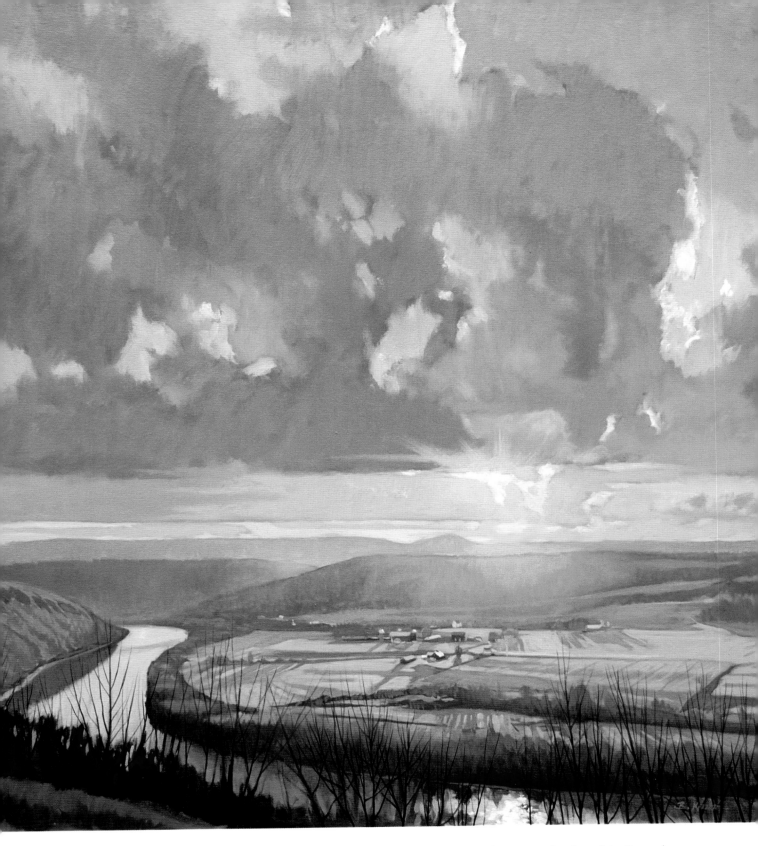

Late Autumn Valley Light
Oil on canvas on panel. 44" × 48" (112cm × 122cm)

This study of light, sky and clouds presents the view of the Susquehanna River as it winds south. It shows the effects of afternoon light as it plays across the French Azilum valley below it.

What Will Your Sky Say?

Caravaggio was said to have regarded still life painting as the highest genre of art, I suspect because of its potential for being directed by the artist. So, to take that idea further, it could be easily argued that skies have even more creative potential than still life, as we can control, choreograph and compose with greater specificity.

As with all compositions, it is important to first consider the broad overall relationships and basic divisions of space—whether the sky is a slim sliver of light at the upper edge of the canvas or a wide swath filling most of the format. Clouds and skies offer a fair amount of latitude and room for creating arrangements that really reflect our wishes.

With that said, when determining what you want your sky to say, think about fundamental concepts such as light and shade, color and, surprisingly, perspective. Yes, believe it or not, perspective in the skies comes into play often, but not in quite the same way as the ultra-defined aspects of linear perspective in a cityscape. The atmospheric effects of weather and humidity, as well as the sizes and shapes of cloud formations and how they follow the curvature of the earth, are factors to consider. In a sense, sky portrayals become meteorological studies and a statement or an impression of a given time and place.

Vernal Light at a Three-Way Stop—Spring Hill, PA
Oil on linen. 40" × 46" (102cm × 117cm)

A sky that supports
In this painting, the early evening sky plays a supporting role, an example of how large, unoccupied spaces serve as an effective device to making the main actors of a composition even more emphatic. The old farmhouse, streaking light and barn share the lead roles in this scene. In the sky, however, I have judiciously placed a couple of small clouds in a key spot for interest.

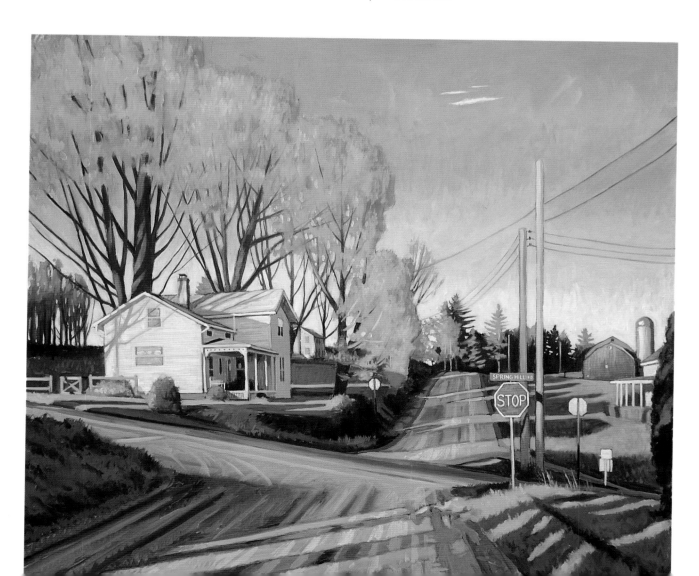

Mid-August Eve—Stonington, ME
Oil on linen. 26" × 30" (66cm × 76cm)

Capturing a fleeting moment
This view of the harbor was roughed in very generally on location in an attempt to capture the fleeting early evening light. The details and final articulation were added later in the studio. The fading light of the sun was warm and gave the upper section of the house and treetops a golden color. The house was actually a light green, but I decided to let my interest in the color of the light take precedence rather than the actual or "local" color of the scene.

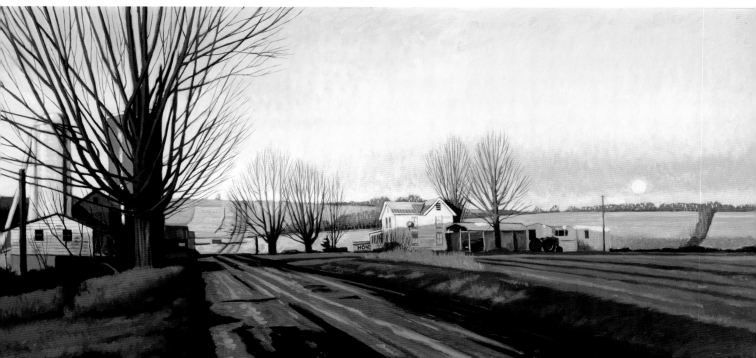

Edinger Hill Moonrise
Oil on panel. 22" × 48" (56cm × 122cm)

Transitional colors
A transitional time is depicted here. A full moon rises while the last warm rays of the sun gradually climb the buildings and forms. The clearness of a January evening and a cloudless sky inspired me. The moon ascending on the far right becomes an intriguing counter-interest to the sun setting behind me. This time of day often has the horizon turning a delicate pink, and in this case I have accentuated that hue somewhat, using Alizarin Crimson, Permanent Rose and white.

Conveying the Clouds

The process of painting clouds on location shares some similarities to figure painting and portraiture when done from life. Painting clouds or people in large part involves memorization, visualization and creativity. When we look at our subject and then back to our canvas, there is an inherent act of memorizing that is necessary. We must retain that visual impression long enough to portray the scene while we paint, before we look back to refresh our memory.

Clouds bring this process to the forefront, as they are often buffeted by winds and therefore are always in flux. In a way, they underscore the impermanent and changing nature of life itself, as they show us from minute to minute how transformation is ongoing and how the continual morphing from one state to another is always occurring.

So, when we paint outside, sometimes the clouds are captivating and engaging, and we just choose to express the forms and combinations that we find appealing. At other times we need to use a combination of invention and memory, as we will see cloud structures and then we'll need to re-create them before our impression vanishes. Often I will incorporate particularly memorable cloud formations that I witnessed before into the current painting. Having a visual catalog of cloud combinations in your head to draw upon is useful. The challenge is to be aware of how these created clouds are interacting with each other in the present composition, within the overall painting.

When painting clouds in a studio work, I often have a visualization of the particular cloud structure to be illustrated. This includes the perspective, light direction, arrangement of major shapes and color scheme.

The type of clouds you are painting should also be considered, and a general familiarity with meteorology is helpful. Clouds are often soft-edged, but there can be some latitude here as well. The rule of softening edges and decreasing contrast in the distance applies to clouds just as it does other elements.

Seneca Cumulus
Oil on linen. 26" × 30" (66cm × 76cm)

Overlapping clouds to show space and distance

Often when I am painting clouds, I borrow from memory or sometimes even combine my observations in nature with bits of inspiration I can recall from other artists. In the end, I come up with a distilled version of clouds that are unique to my vision. In this work, the clouds recede to the right and up the length of the lake, which is to the north. The dark horizontal bands of clouds—often observed on summer days, when thunderstorms are threatening or have recently passed—recede west, from right to left. They are layered in front of the large cumulus clouds and project closer to us. Below the large white clouds is a smaller group of the same type near the horizon.

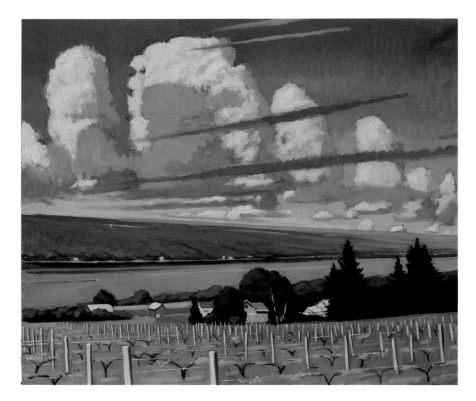

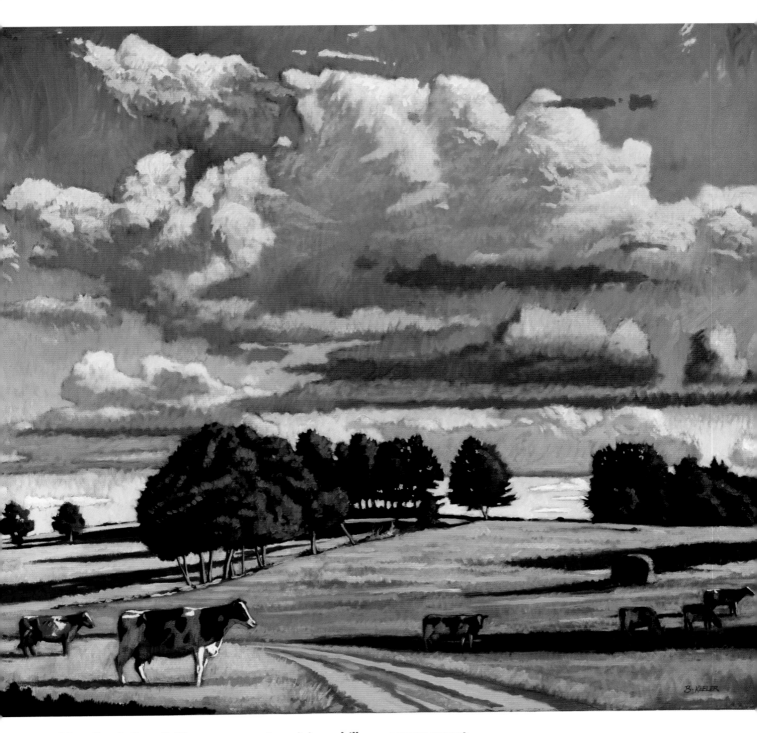

Golden Clouds Over Sullivan County Cows

Oil on linen. 36" × 40" (91cm × 102cm)
Permanent collection of Pauly Friedman Art Gallery, Misericordia University, Dallas, PA

Imagining a billowy arrangement

The inspiration for this work was derived from a view near Dushore, Pennsylvania. This painting is not a literal depiction. The clouds were invented but based on observation, as that summer featured several weeks of the most amazing clouds. These clouds were robust and billowed with great dynamic energy over the warm-colored fields. Even though these clouds were entirely invented, at the inception I had a general vision of how they were to be composed, as well as the warm palette I planned to use. I started with large masses of color as I carved out their general shapes, while keeping in mind the overall design qualities. In subsequent painting sessions, I began articulating the roundness of the clouds by building up the lights in the sunlit areas and lighter midtones in the shadows. The blue of the sky was muted with Burnt Umber or Raw Umber so as not to compete with the clouds.

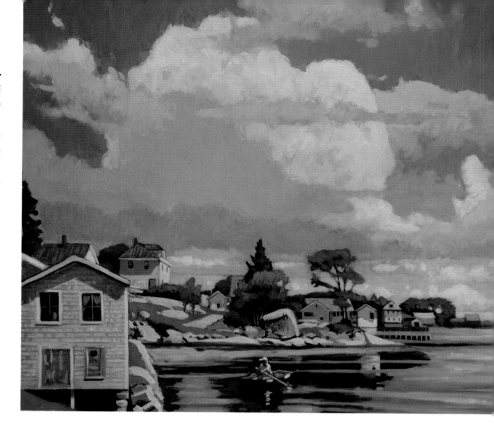

The Morning Row— Stonington, ME

Oil on linen. 26" × 30" (66cm × 76cm)

Value shifts indicate depth

The clouds in this work were conceived in terms of large masses first, with the big white area being the main section. Then the process is to subdivide and layer to create interest and depth, as this is actually how clouds frequently look. In some areas the value switch will create depth, as is the case with the slightly darker gray clouds, which read as being in front of the white clouds. The shifts in value in specific areas, along with layering, combine to help organize the clouds while creating movement and the look of airy, shifting forms. To see a video clip of me painting this scene, visit briankeeler.com.

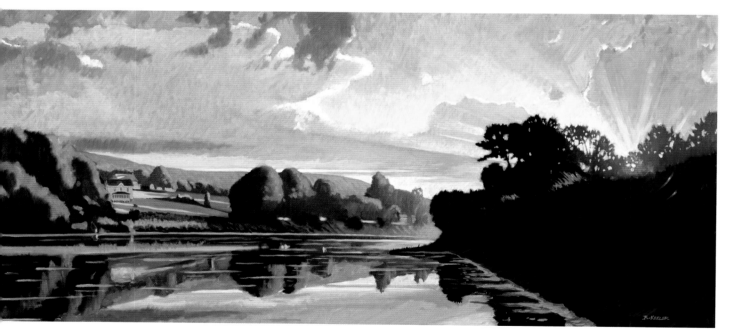

Solstice River Clouds— Sugar Run, PA

Oil on panel. 22" × 48" (56cm × 122cm)
Collection of Dona Posatko, Dallas, PA

Adjusting cloud colors to the light

Painting next to this river island provided a spectacular view of the sun melting into the trees. The sun's rays of light depicted in this scene are known as crepuscular light (derived from *crepusculo*, the Italian word for "twilight"). The varying warm lights create a magic feeling on an evening such as this. The chroma in this work is intensified to augment the drama of evening summer light; I used some Cadmium Reds and Oranges along with various yellows in the trees near the sun. The dark value of the foreground trees also draws attention to the area, as the contrast and chroma are strongest near the sun.

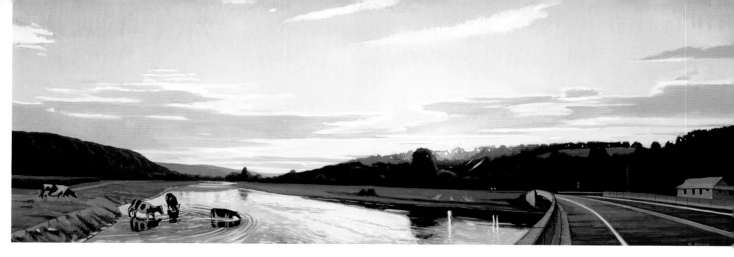

August Evening—Wyalusing Creek
Oil on panel. 22" × 48" (56cm × 122cm)

Figure/ground relationships switching across the sky

I created this oil in my studio from a study I made after riding my bicycle up to the bridge on Route 706 near Lawton, Pennsylvania. I was pleased that I could paint the cows while they were moving. This expanded format includes the bridge with a wider view not easily attained while doing field studies. In this work, the clouds closest to the horizon were generally perceived as being mid or light value against an even lighter background. In the upper sky, the figure/ground relationship flips, as the clouds are light against the darker blue. Near the sun, the clouds have several layers of paint, as I gradually kept lightening, warming and softening edges.

Summer Lake Heat—Ithaca, NY
Oil on panel. 30" × 36" (76cm × 91cm)
Collection of Michael and Allison Riley,
Ithaca, NY

Complementary cloud colors

This studio painting, based on plein air studies, was completed with a mostly warm palette. The large clouds were organized into two major areas. Closest to the viewer and on the left is an area of cool clouds, made with a variety of blues and white but mitigated and warmed with Naples Yellow and Yellow Ochre. So even though these clouds are relatively cooler than the clouds to the right, they are mostly a warm gray. There are two areas of warmer and darker orange near the top. There is also a layering and overlapping occurring, indicating a recession of space to the right, which is up and north on the lake.

Seeing and Stating the Light

The portrayal of light is one of those fascinating and ephemeral aspects of nature that has captivated the attention of many artists. The depiction of light often becomes the main goal in my paintings, while the land or subject can take on more of a supporting role.

When we paint, it is often said that we are portraying the play of light and how it describes the world we see. Regarding light as the protagonist in a work of art can cause a shift in our perception when observing and painting. The drama of strong light on an evening landscape or cityscape actually helps me make an initial simplified statement. I like the look of simplified areas that reveal the underlying geometric beauty. If we think of the plein air oil studies of Corot, a French landscape painter, done in the Roman Forum or elsewhere in Italy, we begin to appreciate the economy of line and shape to reveal light and form. So, using light, I attempt to break down any given scene into large areas of light and dark.

Sometimes this can be the difference between the sunlit areas and shadow, or in a night scene, the large masses of land against sky. As with all types of painting, the key to color and light is value distinction. The separation and orchestration of any subject into clear areas of tone and value really trumps the color. But, after you have made important value decisions, the color can be a source of reward and exhilaration as you explore the range between soft nuance and strong emphasis.

Riverscape with Heron
Oil on linen. 44" × 64" (112cm × 163cm) triptych
Collection of Willa Falck, Golden, CO

Saving the most captivating lights for the sky
In the study for this work, the sun was at times filtering on top of the tall grass on the island and elsewhere. In this studio version, I simplified the overall figure/ground relationship to have the lights mostly in the sky and the darks below the horizon, but with some alterations here and there. The heron rising suggests an inherent spiritual quality.

Light patterns on snow

The relatively high eye level accentuates the inspiration for this painting: the light-dappled yard. The snow was painted rather carefully here by drawing with Burnt Umber the pattern of light and shade. I used cool colors in the snow, as it was reflecting the blue sky above. The house, however, was painted with warmer colors, even though it is also a variation of white.

The old slate walk shown has since been replaced by concrete. But here, the irregularity of the chipped tiles adds character. It was painted with a darker blue/violet hue in the shadow areas, and in the sunlit parts, a warm gray made with white, Burnt Umber and some Yellow Ochre.

First Street, Winter Light—Wyalusing, PA
Oil on linen. 40" × 58" (102cm × 147cm)
Collection of Al and Betty MacLachlan, Wilmington, DE

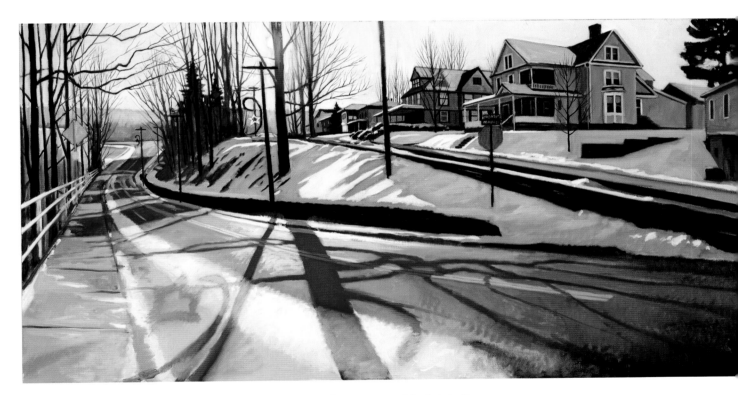

Bridge Street—Star Shadow and Light
Oil on linen. 38" × 54" (97cm × 137cm)

Light reveals topographical details

The title refers to the easy-to-miss pattern of light created by the sun filtering through the Christmas decoration onto the pavement. It is a serendipitous moment, with the ever-changing light moving across the gritty and cinder-strewn road. One reason I like to portray this late time of day outside is that I can more readily experience the transitory and fleeting nature of life. In painting scenes like this, keep in mind the topography of the area depicted. Here, the light is describing the form or topography of the road and the snow-covered bank, revealing how much or how little each is tilting and slanting.

Backlighting for Drama

Backlighting offers a wonderful range of possibilities for portraying light, as lighting from behind inherently provides drama and contrast. In other lighting conditions, we are usually depicting light on and around objects as it comes from a side angle or above. In backlighting, shapes are often silhouetted at a distance from the viewer, with the play of light displayed spreading out in the space between those shapes and the viewer.

The challenge in backlit scenes, perhaps more so than in other lighting conditions, is to get the land to lie flat or in a plane consistent with the perspective. The problem I have seen in some students' work is that the foreground play of light appears to tilt down too much. This is really a perspective and drawing issue, but these off-kilter depictions in the lay of the land seem to come out in these circumstances.

Of course, looking into the light is bad for the eyes, and I infrequently do this in plein air anymore. It is said that this process was a contributing factor to the eventual vision problems of the Impressionist painters of France. So, as we have cameras today, it is better to use photo references to help us paint backlit scenes.

God's Hill Summer Landscape
Oil on linen. 44" × 52" (112cm × 132cm) Collection of Harry Lee, Stroudsburg, PA

Colorful halation effect
Despite the rather dark underpainting, this work contains lots of color. The rows of cultivated fields in the mid-ground lead the eye back to the barn and beyond, following the direction of the light. The hues are intensified along the borders of the shadows, which is a phenomenon sometimes witnessed in photography. As it is used here and in other paintings in this book, the idea is to push the color and create an effect referred to in meteorology or photography as *halation*—a diffusing of light (à la Vermeer) or an aureole (a circle of light) around an object.

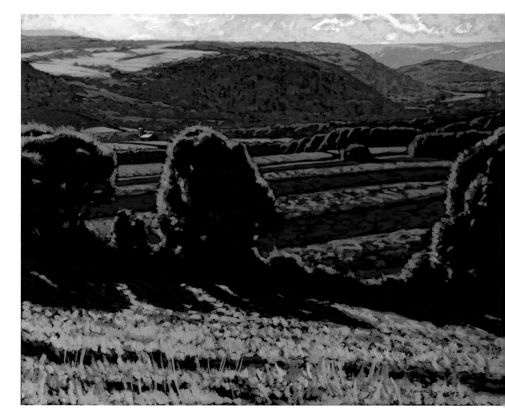

Summer Morning—Sugar Run, PA
Oil on linen. 22" × 60" (56cm × 152cm)
Collection of Williamsport Regional Medical
Center, Williamsport, PA

A departure from local color to translate the warmth of a scene

On many occasions, I've painted sunlight through trees and the way the light plays on lawns and roads. However, this painting, showing an early morning view along the river, also displays the light on quickly evaporating mist. This mist here was portrayed with several layers of color, gradually going lighter and lighter. As the nature of mist is ephemeral, ever-changing and constantly fluctuating between opaque and semitransparent, the challenge was to keep it soft-edged but still describe the shapes of the spires. I purposely used warm colors in the tree, even though the foliage is green, because my goal was to depict the warmth of a summer morning and the color of light instead of an exact transcription of local colors.

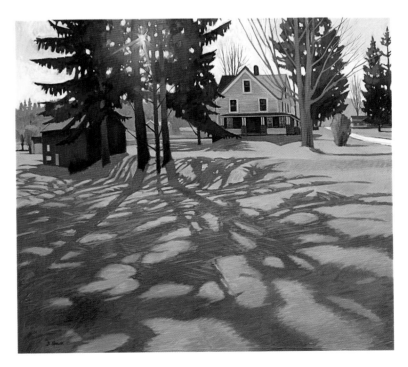

Vernal Lawn Light
Oil on canvas. 44" × 48" (112cm × 122cm)

Taking color chances

The glow of the sun was depicted here by first using very warm hues—Cadmium Red, Venetian Red and Cadmium Orange—but also by lightening the value from the dark green of the tree. In the foreground shadows I took a lot of liberty with the color by selecting a near complement to the local color of the green grass, choosing variations of magenta and high-key violet. The value of this magenta-like color is about the same as the green shadow near the bottom of the canvas.

Water Reflecting the Sky and Land

Water and light combined have together formed another motif that has provided a rewarding muse for many artists. There are many challenges of working with water and sky combined, but many rewards as well.

The work of Maxfield Parrish provides an example of one end of the spectrum, that being of exactness in depicting reflectivity. In certain pieces, he showed a mirrorlike reflection in the water of the scenes depicted above the water's surface. His precision and beautiful color combine to make for memorable works of great beauty. On the painterly side of the spectrum are the brushier painters who exemplified process more than finish, with Eugène Boudin's little seaside oils or Édouard Manet's broad brush and simplified areas in Seine River scenes showing us other options.

As water can be placid and reflective or choppy and not mirrorlike at all, there is latitude for the treat-

ment we choose. There are some constants that are good to keep in mind, but even these can have exceptions depending on weather conditions. One common phenomenon is that the hues are often darker in the reflection, meaning the water is frequently darker than the sky. And as the water is the reverse of the sky, the hues get darker and more intense toward the bottom of our canvas (as the sky gets darker the farther it is from the horizon).

One challenge of portraying water is to seize the serendipitous effects while working in plein air. For example, catching the effect of a breeze as it ruffles a section of water may provide a great compositional device. Another fascinating and challenging aspect to express in paint is how light works in water—its refraction and distortion—and the transparency of water, or how much or how little it reveals of what lies beneath the surface.

Inlet Afternoon—Ithaca, NY
Oil on linen. 36" × 40" (91cm × 102cm)

General reflections of color
In this work the clouds were invented but based on observation. You can see that they are organized according to a perspective plan, as the lower clouds are diminishing in size, overlapping and therefore going back into space. They form sort of a visual aerial echo of the inlet, which is also going back into space. The water had waves from the wind and from the scullers' oars, so it was not glassy like a mirror. Because of this, the reflections could be general and suggestive.

Early May, Foster Branch—Hollenback, PA
Oil on canvas. 36" × 50"
(91cm × 127cm) diptych

Still and moving water
In this work the stream is running over rocks fairly swiftly and therefore not reflecting much, and also not letting us see into the water. A small pool to the lower right, however, is not part of the current and therefore is still, and reflecting the sun and trees somewhat. The sun in the reflection and the actual sunlight are both positioned in dynamic points of the right panel of this diptych. The patch of golden light to the left on the distant hill forms one point of a triangular shape in this design, with the two suns (actual and reflected) forming the other points.

Tiber Evening—Rome
Oil on canvas on panel. 18" × 24"
(46cm × 61cm)

Reflecting man-made structures into water
When painting water with a cityscape or with architecture in the background, we need to re-create the mirrored images of the man-made structures. This combination is appealing, as it shows the flowing river in contrast to the more permanent buildings. Generally, the reflected images are darker than those on the shore, but not always. The flowing current and the ripples add interest and complexity to the water. This nocturne is rather suggestive and impressionistic; the goal was not to render the details too tightly, but to capture the mood and feeling of the ancient city at sunset.

Over Watkins Glen, NY
Oil on linen. 26" × 30" (66cm × 76cm)

Water bathed in sunlight
This view shows Seneca Lake from the east side with part of the town below. The color in this work was suggested very broadly and generally at first, as I was working outside. The overall distribution of shapes, however, was arranged to get the key elements of the sun, reflection, town and figure in strategic positions. The sun was portrayed as seen filtering through clouds, although at the time the clouds were not prevalent. The reflected glint is the brightest value, and therefore the key point to which all other elements relate. The diffuse halation and intensified color in the trees and bale tops is created with Venetian Red or Indian Red with Cadmium Red, and perhaps some Cadmium Yellow Medium.

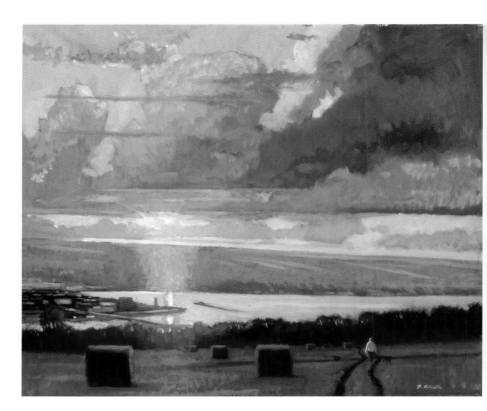

Campfire Smoke, Loyalsock Creek
Oil on canvas. 41" × 45" (104cm × 114cm)
Collection of Linda Graves, Ithaca, NY

Breaking up the water
The values in this work are pushed so that the darks become very dark. There is transparency in the water, as well as an intriguing graphic pattern caused by the current and the reflected areas. I used a more painterly technique in the closest water by making the sun glint and orangish areas have a curvilinear, stylized look. There is a diagonal lighter area going across the water in a slant that breaks up the water's progress. Further into the work, a horizontal band of light near the campfire provides another break and a resting spot near the eye level. I did a small plein-air oil study of this same scene where the eye level was placed much lower. However, with the eye level shown here, the foreground water becomes more predominant.

Sun Glint on the Inlet
Oil on linen. 18" × 20" (46cm × 51cm)

Land, water and sky sharing the same warm hues

This depiction of late afternoon uses warm colors, sometimes even hot hues, throughout. The glint of the sun is causing halation around the women in the boat, and the hues are more intense here as well. Cadmium Red Light, Cadmium Yellow Medium and Lemon Yellow are some of the colors used in these areas and also in the trees.

Night Skies

Nocturnes provide us with an opportunity to explore a more poetic and mysterious side of life. Nighttime scenes also afford us the chance to work with a limited palette and explore the beauty of soft edges and diffuse light.

The night sky as well can suggest many possibilities as it opens to the astral infinities and contrasts with our relatively small place in the grand scheme of things. Nighttime in townscapes and landscapes allows us to have fun exploring the beauty of nature interacting with man-made elements and artificial light from streetlamps and houses.

Some plein air artists work outdoors at night, with various ways of lighting their work and seeing their palette. I have done this on occasion, most recently in Rome along the Tiber River, where the adjacent streetlights provided enough working light and the promenade next to the water has few pedestrians for most of the year, which makes for undisturbed working.

Still, for me and for most other artists, the practicalities of working outdoors at night are just too much trouble. Instead, working from photos or memory or sketches seems to be much more effective.

Night art

Art history provides us with plenty of nighttime inspiration, if just gazing at the evening sky is not enough. Some memorable examples are James McNeill Whistler's views of the Thames River in London and Frederic Remington's Old American West scenes. Edward Steichen also did some beautiful oil paintings of nocturnes. One of the most recognizable night scenes of all is Edward Hopper's *Nighthawks*, but his other works of voyeuristic views of city offices and windows and lonely gas stations at night are equally powerful.

Stonington Nocturne
Oil on linen. 10" × 14" (25cm × 36cm)
Private collection, Lewisburg, PA

The atmosphere of night

This nocturne uses a blue/gold combination, and the painting recalls to me some of the night scenes of London painted by James McNeill Whistler. I purposely arranged the reflections in the road to mirror the house, which is the central actor in this study. The distant shoreline is kept more diffuse to indicate the night atmosphere.

Susquehanna Nocturne
Oil on panel. 14" × 16" (36cm × 41cm)

Dividing the night

This work also has a blue/gold color scheme, and the overall composition is simplified into distinct areas of sky, trees, river and shore. The figures and campfire occupy a key point and are located in one of the "sweet zones."

Close Call—Sugar Run, PA
Mixed media. 20" × 36" (51cm × 91cm)

Nighttime value contrasts

Night scenes in general offer an opportunity to simplify, and in this work (along with others shown in this section) the land and trees occupy the darker areas and sky is lighter. Value is doing a fair amount of the describing here. For example, the house is defined by being a light shape silhouetted against a dark mass of trees. The value and hue of the warm, glowing lights contrast with the overall bluish hue of the rest of the image. The deer also contain some Raw Umber or Raw Sienna, which accentuates them due to the warmth of these colors. I used all the media in my arsenal—oil, watercolor, gouache, pastel and charcoal—as an experiment to see what could be accomplished.

Keuka Nocturne
Oil on linen. 10" × 10" (25cm × 25cm)

A palette of blues
A monochromatic palette of variations on blue is at work here, with the values fairly close together throughout, except where the darks are pushed in the trees and then the lights are pushed brighter in the clouds and town lights. The clouds are not as resolved here as in some paintings, but this work served as a study for the larger oil of the same scene shown on the bottom of page 95. The clouds were thought of here as they drift across from west to east, with a few bands of clouds in a Cerulean-like blue to create contrast in value and temperature.

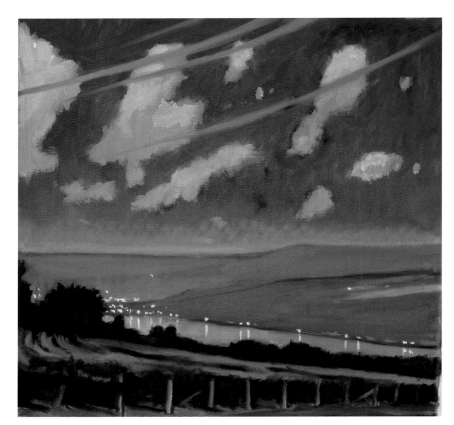

Seneca Nocturne
Oil on linen. 10" × 10" (25cm × 25cm)
Collection of Justin Dempsey, Washington, D.C.

Darker land, lighter sky
As sometimes happens, I stay until after sunset when painting daytime or evening scenes and then get to observe the same locale while night begins to envelop the land. In this painting, all the values have been pushed dark—for example, the distant hillside is much darker than in *Keuka Nocture* (above). I love the twinkling of a few cottages and homes as the night descends and often paint these with flicks of gold and Yellow Ochre with white. The clouds are positioned high, so as to suggest air currents pushing them across the sky, and recede to the right.

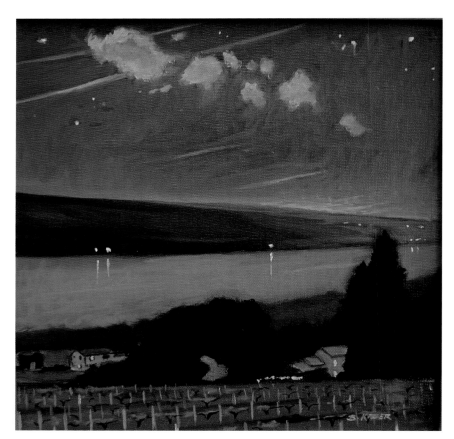

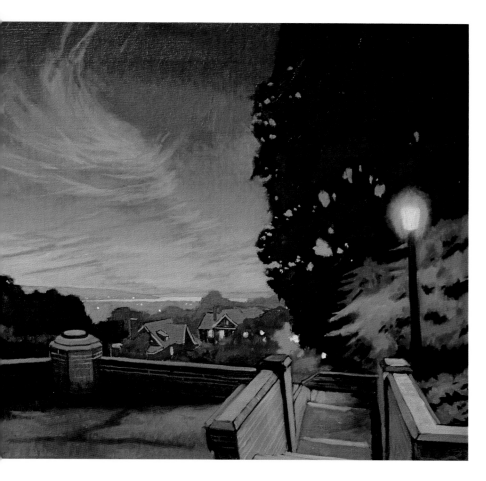

Twilight Over Ithaca
Oil on linen. 18" × 20" (46cm × 51cm)

The last effects of sunlight as night falls

The clouds in this work are done in gold and saffron-like colors to suggest the last rays of warm sun still shining up from below the western horizon. The clouds here are the wispy, mare's-tail types that lend themselves to suggesting currents or flow of air. The streetlight in the photos used for reference had a eerie greenish tint that made the foliage look rather iridescent.

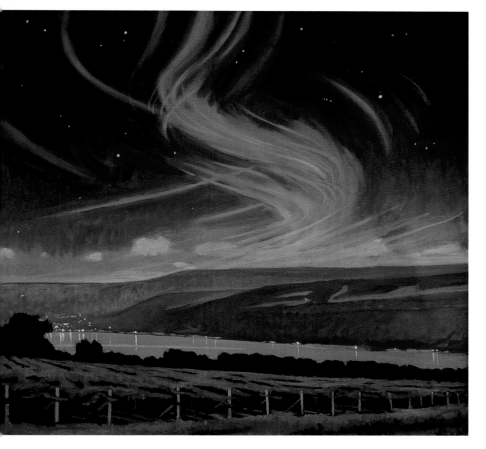

Keuka, Nocturne with Mares' Tails
Oil on linen. 26" × 30" (66cm × 76cm)

Night breezes

In this work the clouds were organized to suggest swirling night breezes. The foreground was pushed darker in value, and the details of the vine posts and increased contrasts of this land area were used to augment closeness and depth.

Moonlit Street: Maximizing a Cool Palette

The main goals in this painting are to portray a nighttime scene with a limited palette—blue and yellow—contrasting in both temperature and value, and to create a poetic kind of mood that suggests the quiet life of a village. The lone figure walking on the right and the interior light, to the left, serve as brackets and supporting actors to frame the main interest of the Victorian house in the background, with a stark, single illumination. Although the colors are basically primary, they are shifted or adjusted to be more nuanced than colors taken directly from the tube, or color-wheel-perfect primaries.

MATERIALS

SURFACE: Stretched medium-weave linen, 26" × 30" (66cm × 76cm)

PAINT COLORS: Alizarin Crimson • Black • Burnt Sienna • Burnt Umber • Cadmium Red Light • Cadmium Yellow • Cerulean Blue • Chromium Oxide Green • Cobalt Blue • Naples Yellow • Permanent Rose • Phthalo Green • Prussian Blue • Ultramarine Blue • Venetian Red • White • Yellow Ochre

OTHER: Neutral Gray acrylic paint (Utrecht) • Mineral spirits

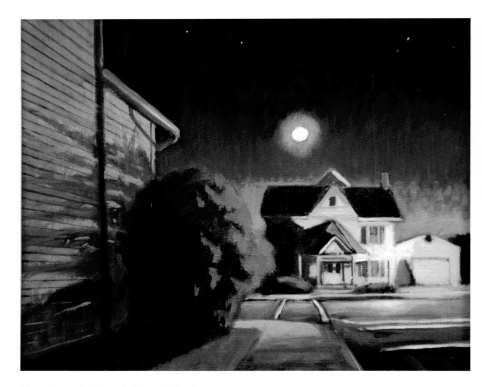

Senate and Church Street Nocturne
Oil on linen. 10" × 10" (25cm × 25cm)

Oil study

This is the original small oil study where I explored the theme before starting the larger version. The shadows on the left and the overall ambience of night light are what attracted me to the scene.

1 Make a sketch with more sky

Tint the surface with Neutral Gray acrylic first. In the initial stage, draw the image with attention to perspective and proportional relationships. The "X" marked on the door of the distant house indicates the vanishing point to which all the perspective lines lead.

I changed the overall composition significantly compared to my original study. Mainly, I added lots of space in the sky above the town, thereby accentuating the positioning of key elements to put them into a more effective location. For example, the vanishing point, streetlight and lightest values on the garage are clustered around a "sweet zone," or dynamic point, in the lower right.

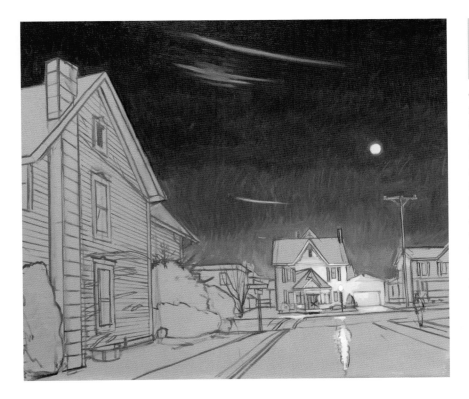

2 Set up the sky and begin the distant house

Begin to apply the first layer of color to the sky and to the distant house, setting up the blue/gold color scheme. Mass in the sky with a thinly painted layer (using a fair amount of mineral spirits) of Ultramarine Blue and Prussian Blue with white. Skies almost always get lighter at the horizon, even at night, so lighten the blue as you get closer to the buildings. Apply Naples Yellow, Cadmium Yellow and white to the distant house, as the streetlight is creating a warm glow.

Begin to add details and model form as you go. Also consider the moon's placement in the sky. Make little compositional decisions within each area of the work. In other words, consider not just the composition as a whole, but also the smaller subdivisions of space, which also have their own arrangements and relationships. The clouds are part of this; add them to create somewhat soft borders that keep the viewer's eye within the canvas.

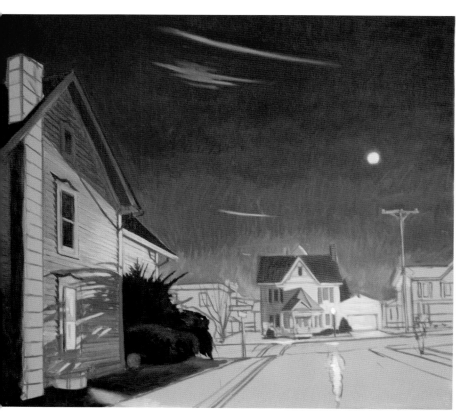

3 Develop the houses as affected by the light

This composition has three main focal points: the moon, the distant house lit by the streetlight and the lit window of the nearest house. Begin to paint the pattern of light on the nearest house, applying a cool hue made with Cerulean Blue, Ultramarine Blue and white. I let the Burnt Sienna lines remain in areas (such as the clapboards) to offer a warm contrast and also because I like the drawing to show. Paint the shrubbery with Phthalo Green, Alizarin Crimson, some Ultramarine Blue and black. Using Alizarin Crimson, a near opposite of Phthalo Green, will help make the green dark but very subdued and low-chroma. Both colors are transparent, which also works well for shadows. Paint the grass using the warmer Chromium Oxide Green and some Phthalo Green and Yellow Ochre. Keep the roof of the distant house warm, using Burnt Sienna, Venetian Red and some Cadmium Red Light on the lighter side, and gradually darkening on the left with Burnt Umber.

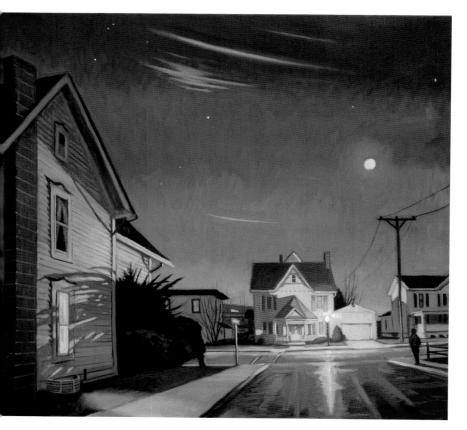

4 The street takes shape

Add another layer of paint to the sky, and work on the details of the houses—shaping the planes of the roof lines and clarifying other architectural details, but maintaining the overall "painterly" look. I corrected the orthogonal lines on the near left chimney.

In this stage, add other variations of cool colors. For example, in the street, add some purple or lavender-like colors, along with some bluish greens. The turquoise is made by mixing Phthalo Green and Ultramarine Blue with white, and the purple is made with Cobalt Blue, Permanent Rose and white. I am keeping the shadows in the distant house warm and the shadows from the shrub beside the foreground house cool—somewhat of an arbitrary decision to accomplish a contrast between the two buildings.

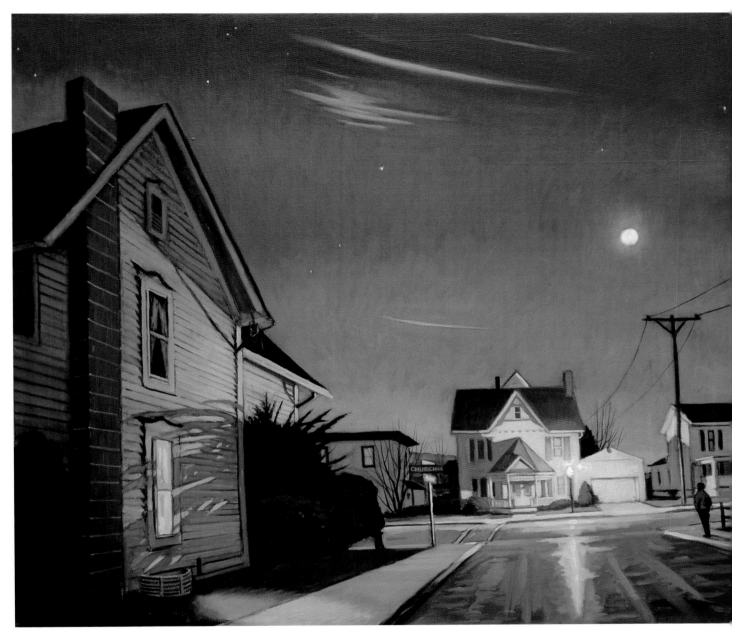

Senate Street Nocturne
Oil on linen. 26" × 30" (66cm × 76cm)

5 Sharpen and soften edges and increase contrast

Add yet another layer of paint to the sky. These layers further augment the graduation of tones from dark at the top to light at the bottom, and add richness to the color. Paint the stars and the diffuse glow around the moon. Add some Venetian Red to the roof of the distant house to accentuate the glow and warmth of the streetlight.

Continue to push the contrasts in certain areas, such as the foreground grass, which can be made darker with a deep green (Phthalo Green and Burnt Umber). This process solidifies the darks to make them appear unified. Make the edges in certain foreground areas more crisp, and in some areas soften the edges, such as where the distant mountain (above the street sign) meets the sky.

Beach Sky: Trying a Scene in Two Different Mediums

I was attracted to this scene because it represented a certain type of summer's-end ritual, as it was early in September and was probably the last time these families, couples and individuals would be by the sea that season. I liked the contrasts presented: the raw nature of the land jutting into the ocean with the simplified geometry of the built structures; the rounded organic shapes (the clouds and figures) with the angular aspects of the houses and rocks; the impermanence of man with the endurance of the earth.

Let's attempt this scene in pastel first, then in oil, noting the differences in color and composition.

MATERIALS

For the pastel version:

SURFACE: Canson Mi-Teintes paper, 24" × 30" (61cm × 76cm)

PASTELS: Various colors

For the oil version:

SURFACE: Stretched medium-weave linen, 36" × 40" (91cm × 102cm)

PAINT COLORS: Black • Burnt Sienna • Burnt Umber • Cadmium Orange • Cadmium Yellow • Naples Yellow • Permanent Rose • Ultramarine Blue • White • Yellow Ochre

OTHER: Burnt Sienna acrylic paint (Utrecht)

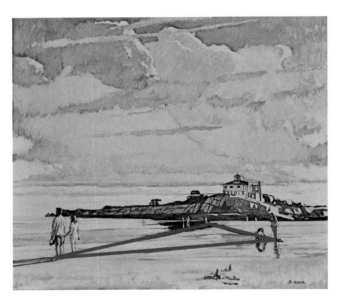

Fictive positioning with a scalene triangle

We will use a scalene triangle (no equal sides) to help us place the figures in this scene, but to make the composition more dynamic, we will introduce the idea of "fictive positioning" as we consider this triangle. Instead of seeing the triangle as flat on the picture plane, imagine it laying flat on the plane of the beach, leading the eye back into space, with the figures arranged at the corners in such a way that the intervals between them have an intrinsic harmony. Composing in an illusionistic space (or fictive position) can add another element to the idea of composing, which is usually just considered "flat design."

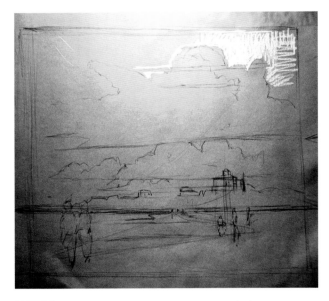

1 Arrange the composition

As you make the preliminary sketch, focus on major divisions of space, both vertical and horizontal, and articulate the sequences and intervals. Use forgiving (movable) borders if needed; I didn't have to adjust them for this particular piece. This very early stage illustrates the idea of fictive positioning just described; notice the triangular manipulation of the figures placed on the beach. Arrange the clouds to adhere to a perspective plan, diminishing them in size as they approach the horizon. Use vertical plumb lines near the house in the distance to see how the figures align with the other elements.

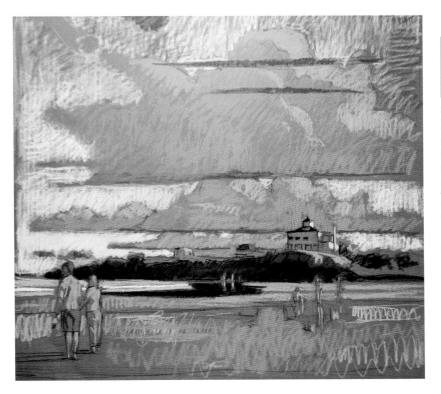

2 Block in the main elements

Block in the light areas using a golden ochre color. The forms are developing as you clarify the lights. Begin the color in the clouds using high-chroma hues—in this case, a rose hue in the shadow areas and a golden ochre in the sunlit areas. These two colors are just slightly off of the perfect color wheel opposites of yellow and violet, to make them more sophisticated and appealing. In the sand and reflected clouds in the foreground water, use the same gold and rose combination. In the shadow area of the rocks, use a dark blue similar to Prussian Blue. For the sky, use a pastel similar to a light Ultramarine Blue, lightened even more with white.

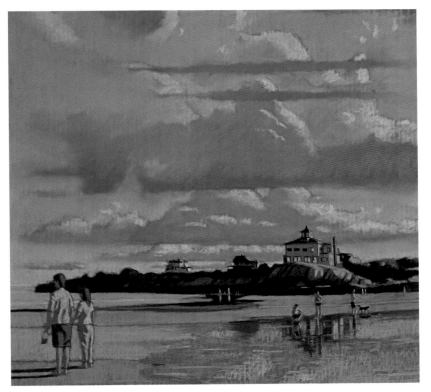

3 Cool off the clouds

The finished pastel maintains the dyad scheme but with color blended using the fingertips. As this pastel painting progressed, I moved the hue of the shadow areas of the clouds more toward the blue and minimized the yellow in the light areas. The rich colors of the clouds are reflected on the foreground water.

This time of day is occasionally referred to as the *golden hour*, and hence the contrasts of warm and cool as well as light and dark are accentuated. Consequently, this particular dyad of yellow to violet seems to appropriately express the drama and beauty of this time of day.

Gloucester Afternoon
Pastel on paper. 24" × 30" (61cm × 76cm)

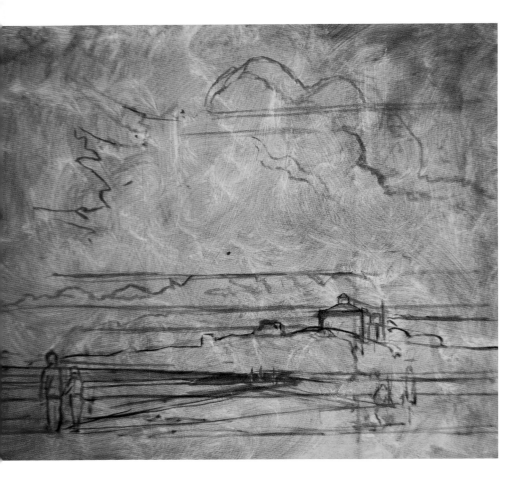

1 Arrange the composition

Use the finished pastel on page 101 as a reference as you begin this oil. Sketch the drawing quickly on canvas tinted with Burnt Sienna acrylic. In keeping with the fictive positioning concept of composition, I have drawn a triangle on this oil in the beach area (just as in the drawing step of the pastel demo) to indicate the relationships of the groups of figures and how the beach itself recedes into space, with corresponding diminution of the size of the figures.

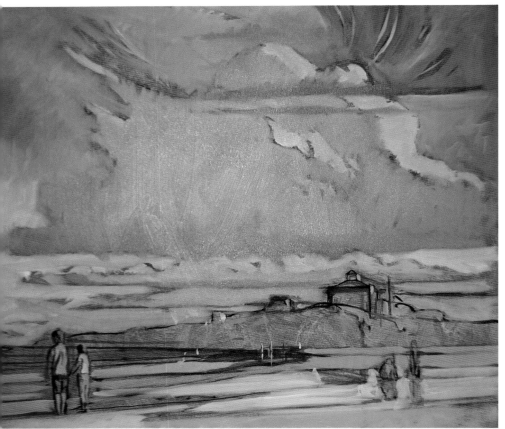

2 Block in the main elements

Mass in the forms and major light areas, as you did in the pastel demo. Here, I've decided to make the cloud shadow side a warm tone. Create this warm gray in the shadow area of the clouds with a mixture of white, Yellow Ochre and some smaller amounts of Ultramarine Blue. Keep the sky a relatively lower chroma of blue by mixing Ultramarine Blue with some small amounts of Burnt Umber. The idea is to create the soft atmospheric quality of diffuse light rather than the intense hues of midday.

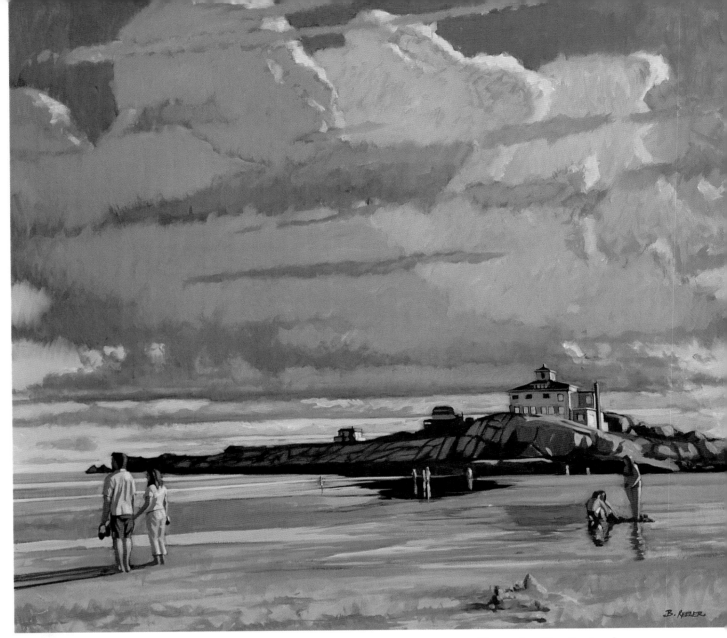

Gloucester Sky, September
Oil on canvas. 36" × 40" (91cm × 102cm)

3 Rearrange the clouds and fine-tune the colors

The biggest change made involved rearranging the clouds to be less symmetrical and more dynamic. The clouds are organized into four major banks, and the shadow area of each is a different hue and value. Although the dyad treatment is not as prevalent as in the pastel version, there are still subtle nuances of the violet and yellow color scheme. The light on the clouds is a golden hue of late afternoon with orange accents, and the clouds (reflected in the water) veer toward blue-violet. The intense orange (Cadmium Orange plus Cadmium Yellow) on the central cloud is placed at the transition between light and shadow. Paint the main area of the foreground cloud using Ultramarine Blue, Permanent Rose, some Burnt Umber and white. Make the other clouds lighter and warmer, using varying amounts of white, Permanent Rose, black and Yellow Ochre. Paint the foreground beach and light areas of the rocks with a mix of Yellow Ochre, Naples Yellow, Cadmium Orange and white. Paint the shadow area with Burnt Umber, Ultramarine Blue and black. Mix the midtone of the lighter rocks in the shadow area using the same combination, lightened with Yellow Ochre and white.

Paint the foreground beach and light areas of the rocks with a mixture of Yellow Ochre, Naples Yellow, Cadmium Orange and white. Paint the shadow area with Burnt Umber, Ultramarine Blue and black. Mix the midtone hue of the lighter rocks in the shadow area using the same combination, lightened with Yellow Ochre and white. Although this painting features the sky, the concern with the arrangement of the figures still allows me to think of it as a figurative painting.

conveying
perspective

A painter can implement perspective with a modicum of study and research from books and online sources. Conversely, many scholars and scientists have proven that perspective can also be an exhaustive, mathematical and technical investigation. This chapter outlines a few key concepts and describes how to use linear and aerial perspective techniques to paint realistic imagery that is more believable. By considering some perspective basics at the onset or inception of any painting, we can make our compositions stronger and more organized.

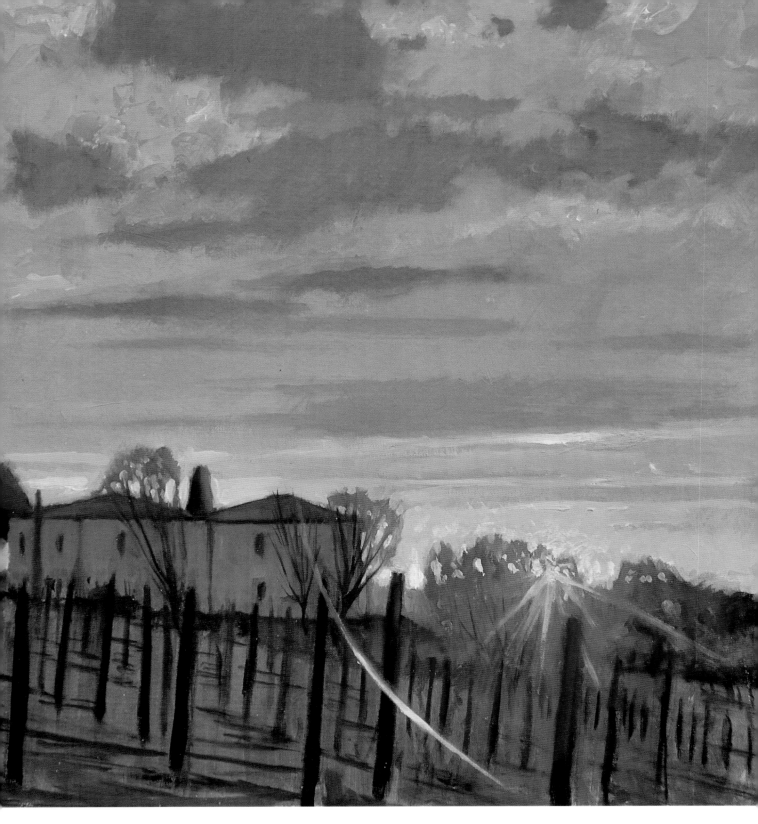

January Evening—Vineyard in Perugia
Oil on linen on panel. 18" × 20" (46cm × 51cm)

This was painted on location just outside of the northern wall of the ancient city of Perugia in Umbria, in central Italy. Many days in the winter are not so cold in Umbria as to make plein air painting overly difficult. Here, there is a perspective set up by the vineyard posts (all suggested quickly with thin paint) that are receding back and up a hill to the left. The house was seen straight-on, more or less, so there were no orthogonals or other linear perspective issues. Aerial perspective is suggested by the diffuse golden light near the setting sun and the gray of the distant mountain.

Perspective Terms to Know

The following list reviews some of the basic terms necessary for relating to perspective in art.

Linear perspective | A type of perspective in which depth is conveyed by the recession of objects into space and parallel lines that appear to converge in the distance.

Aerial (or *atmospheric*) **perspective** | A type of perspective in which atmospheric effects are used to create depth. Think of the effects of moisture in the air, which makes distant mountains appear bluish and diffuse.

Cone of vision (or the *optic cone*) | The standard 60-degree area visible to humans without turning the head or eyes. Wide-angle lenses extend this area, and telephoto lenses decrease it but magnify the view.

Picture plane | An imaginary vertical plane placed between an object and the person viewing it, representing the division between the portrayed space and the viewer.

Ground line (or *base line*) | A horizontal line on the ground or floor at the base of the picture plane.

Horizon line (or *eye level*) | A horizontal line representing the eye level of the viewer. Establishing this reference point is crucial to creating realistic art, especially where perspective issues are predominant. The placement of this line on the paper or canvas is also an important initial consideration for composition.

Ground plane | The surface upon which objects are placed.

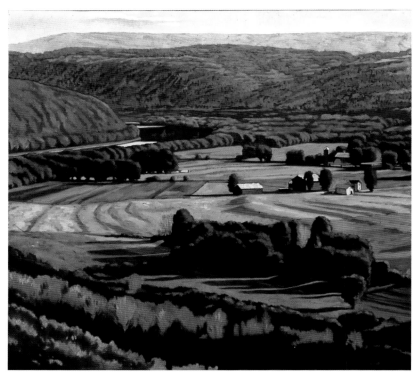

River Valley—French Azilum, PA
Oil on canvas. 36" × 40" (91cm × 102cm)
Private collection, NJ

Aerial (or atmospheric) perspective
The aerial perspective is depicted here by suggesting the effects of atmosphere in the distant mountains. The closer range is painted with blues in the shadows and greens in the lighter areas where the sun hits. The next range of mountains behind it contains similar hues, but with lighter values and less value contrast than in the rest of the painting.

Station point (or *vantage point*) | The intended position of the viewer's eye as the painting is observed.

Point of sight (or the *center of vision*) | The point on the horizon line directly in front of the viewer, corresponding to the vanishing point in one-point perspective. This point is usually plotted by the artist on the paper or canvas for reference.

Vanishing point | The point or points on the horizon where receding parallel lines appear to converge.

Orthogonals | In linear perspective, diagonal lines that can be drawn along receding parallel lines to the vanishing point.

One-point perspective | Linear perspective where all the parallel lines appear to recede to a

The cone of vision

This illustration shows how we typically understand the optic cone of human vision. We have a 60-degree arc of inclusiveness in our vision, which extends both to the side and up and down. The area outside of the cone is considered peripheral vision.

The optic cone in a street scene

This sketch suggests how much a typical visual cone would include in a street scene. The smaller the space, the smaller the visual cone area will be. The inside of a room would have a smaller visual cone, but as we go outside, as shown here, the space expands.

single vanishing point. Examples of absolute one-point perspective are elusive and usually don't adhere to the perfect model; a slight shift from a direct frontal view of a building in a scene will reveal other vanishing points.

Two-point perspective | Linear perspective where all the parallel lines appear to recede to two vanishing points, which in paintings are almost always located off the paper or canvas. Two-point perspective is easily observed when standing at an angle to a building (see page 109).

Three-point perspective | Linear perspective in which all parallel lines appear to recede to two vanishing points on the horizon and also a third point far above or far below. This is easily visualized by imagining your vantage point to be at the corner of a tall skyscraper, with the parallel lines diminishing skyward as well as to the left and right.

Foreshortening | Shortening the lines of an object, thereby distorting its shape, in order to create the illusion of that object receding into space. For example, any perfect circle in a realistic scene would be depicted as an ellipsis.

Foreshortening

In this painting, the train cars are viewed from an angle that incorporates foreshortening. We also see an expansion upon what is normally seen within our optic cone. The panoramic or wide view presented here would require turning your head to the left and right to take in the scene as shown in this painting.

Clouds Over Cayuga
Oil on canvas. 12" × 48" (30cm × 122cm)
Collection of Rich Benson, Ithaca, NY

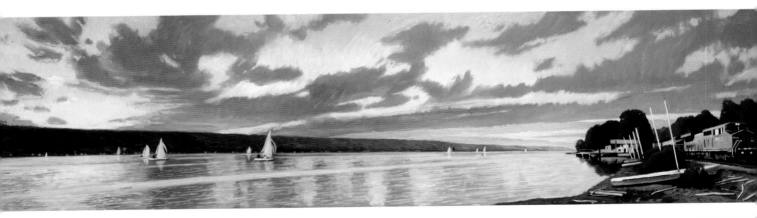

Linear Perspective

A knowledge of perspective is a necessary and valuable tool to understand and use in your work to assist in creating realistic images, especially when buildings are involved. However, perspective comes into play in many other ways when there is no architecture shown—for example, in getting fields to appear to have the right depth and lay flat in the plane depicted, with the correct angles.

Understanding the many aspects of perspective can be rewarding and beneficial to augmenting the appeal of realism in your work. But, I don't believe it is necessary to be mathematically rigid (especially for plein air work), as one would see in a mechanical drawing. Understanding some of the basics, however, is required. Knowing about eye level, orthogonals, vanishing points and atmosphere will provide you with some essential starting points, and with practice at observing and then drawing and painting, you will gradually become more proficient and see improved results in your work.

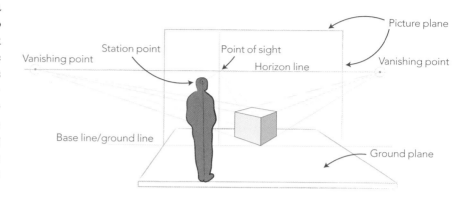

Looking at a scene in perspective

Illustrated are several of the terms defined on the previous pages. The front edge of the cube is butting up against the picture plane and on the base line; here it is seen from above. Our vantage point is even above and behind our model viewer shown. Because we are above him, his head is not aligned with the eye level/horizon, but from his position, the horizon is always at eye level. Think of the picture plane as an imaginary transparent sheet behind which all the objects are placed. Our space is in front of the picture plane; all the objects in a given scene are behind this imaginary plane.

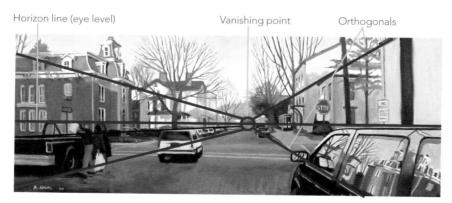

Loading Spackle—Lambertville, NJ
Oil on canvas. 10" × 30" (25cm × 76cm)
Private collection, Lambertville, NJ

One-point perspective

This street scene painting employs one-point perspective. The point of sight and vanishing point coincide at the end of the street, with orthogonals (perspective lines), such as street curbs and building lines, converging there. In this painting, the wide-angle reference photos I used stretched the standard 60-degree area that is typically visible to us, thus extending the optic cone, or cone of vision.

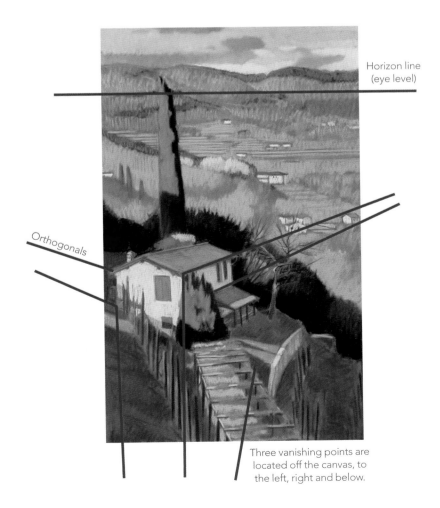

Horizon line
(eye level)

Orthogonals

Two vanishing points are located
off the canvas, to the left and right.

Goats Playing as Hood Ornaments and Weather Vanes
Oil on linen. 32" × 40" (81cm × 102cm)
Collection of Woody Woodland,
North River, NY

Two-point perspective
In this example of standard two-point perspective—best observed when looking at buildings from an angle—all the orthogonals converge at the two eye-level vanishing points, located off the canvas to the left and right.

Combining goats with a small-town setting appealed to my sense of the irrational, and the non-sequitur-like aspect they presented. I have heard that climbing on cars is a feat sure-footed goats can easily do, much to the consternation of their owners. This scene was imagined but inspired by the well-manicured settings of the northeastern United States.

Horizon line
(eye level)

Orthogonals

Three vanishing points are located off the canvas, to the left, right and below.

Vignola View, Barga
Pastel on paper. 28" × 18" (71cm × 46cm)

Three-point perspective
My vantage point here is from above, allowing a slight three-point perspective. I usually tend to minimize the third downward or upward vanishing point to keep the vertical lines parallel (more or less) to the sides of the canvas or paper. But here, as we are above the garden and house, all the lines of the posts and the sides of the house could be slanted in such a way as to lead down to the third vanishing point at the bottom.

The concept of three-point perspective is usually best understood by standing at a city corner and looking up toward the top of a skyscraper while being able to see down a street to your right and left as well, observing orthogonals in each direction receding toward three vanishing points.

Deciding the Eye Level

We want to create an interplay of effective intervals between objects and divisions of space within our paintings, and the first one of these divisions to determine is the horizontal division made by the eye level placement. Determining the eye level (or horizon line) for your composition will greatly affect your final painting. For example, the two paintings of Rome shown on this page and the next depict the same area along the Tiber River, but as seen from two different angles and at two different times of day, with the eye level significantly different in each. (You can see a video of each painting in progress at briankeeler.com.) Just by considering a simple but fundamental concept of where the eye level is placed, we can open up many options and creative possibilities.

Before you can factor the eye level successfully into a work, you need to be able to find it in the scene you are about to paint. With a view that includes build-ings, one easy way to find the eye level is to simply look for the lines that are horizontal. In a landscape with all organic shapes and objects, the task is more challenging, but elements such as fields and roads or rocks can assist in the discovery.

Once you have determined where the eye level is in the scene in front of you, you must decide where to place it on your canvas or paper. Often I see students automatically plop the eye level smack in the middle, dividing the canvas in half horizontally. This worked for Leonardo da Vinci in his painting of the Last Supper, where he positioned the eye level in the middle, with all the orthogonals converging at the center in the head of Christ. For us mere mortals, however, it is better to create a more interesting and dynamic division of space by raising or lowering the eye level so it's not a perfect division.

Let what you want to emphasize help decide the eye level

This work was done on the promenade along the east bank of the Tiber in Rome, looking upstream toward the Castel Sant'Angelo. The painting was completed mostly on location but with details like the sculler added later. When I first came upon this view one morning, it was the play of light and reflections in the river that I found engaging. Consequently, I needed more space at the bottom. The eye level has been placed just enough above the halfway point of the canvas to be appreciated as an unequal division. However, the bridge, Ponte Vittorio Emanuele II, and Castel Sant'Angelo at the top all become the areas to which our eye is led to and through. The sculler on the river on the left is also heading upstream and into the painting. He serves to underscore the directional momentum of the perspective.

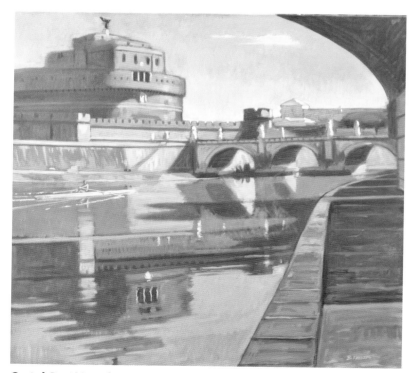

Castel Sant'Angelo, Rome
Oil on linen. 24" × 26" (61cm × 66cm)

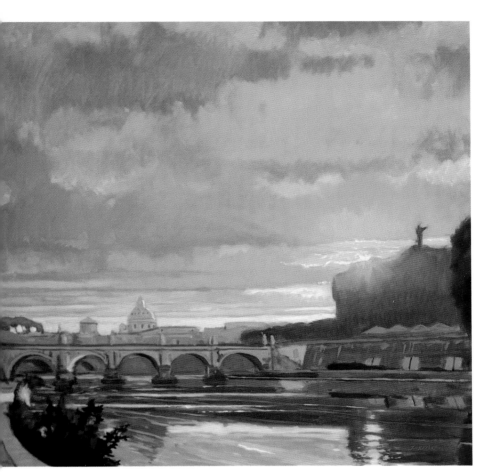

St. Angelo Sunset, Rome
Oil on linen. 24" × 26" (61cm × 66cm)

Open space sharpens the focus

This painting was started late in the afternoon. I plotted where the sun was eventually going to set and planned the painting accordingly. The clouds were invented but based on previous observations. In this oil, I have placed the eye level quite low, about one-quarter up from the bottom. The sky and clouds are an important part of this work, but as background. The extended area of sky serves to bring out the city even more so. Large areas of open space make for effective designs, as they help to accentuate the objects in the other areas.

Summer Rhythmscape— Wyalusing, PA
Oil on linen. 52" × 48" (132cm × 122cm)
Private collection, Doylestown, PA

A view from up high

This view is from an overlook that affords the viewer a vantage point similar to what a bird might see, with a rather extreme foreshortening on the objects below. In this work it was the play of afternoon light on the rolling fields that I wanted to bring out. Therefore the eye level needed to be placed very high on the canvas—running horizontally through the various slanting mountains—to include the expanse of the landscape. This scene could also be depicted with the eye level placed way at the bottom of the canvas, but all the fields would be eliminated, thereby opening up the sky to a possible cloud study.

Analyzing Angles & Their Relationships

Even if you do not bring out the angles observed in a scene, or choose not to exaggerate them in a painting, it is important to learn how to analyze angles and their relationships to each other. This skill is invaluable in portraying any realistic subject.

Establishing perfect verticals and horizontals with a cross drawn on the canvas (which bisects the canvas each way) will help you analyze all the angles within a scene. When looking at the subject, simply use a brush or pencil held up to any given shape to determine how much deviation there is from the perfect horizontal or vertical, and you can apply the same deviation to your drawing. When working from life,

the use of plumb lines—imaginary lines coming either vertically or horizontally from any given object—can also help you accurately place the key features of any subject. The side of the canvas when set on the easel, if it is perfectly vertical, may also serve as a guide, much as the drawn cross does.

Stressing angles brings out a certain clarity in a scene. However, one can choose to minimize the expression of angularity, even though it is perceived and realized. The understating and softening of angles leads to a more feminine, rounded quality, with convex forms emphasized.

Angular emphasis
This drawing overlay on a black-and-white image of the painting shows how appraising and expressing angles can be realized. The compass at the left serves as a guide in determining how much deviation from a perfect horizontal or vertical there is in any given angle. In the painting, there was a purposeful effort to emphasize the angles in the figure and in the folds of the sheet.

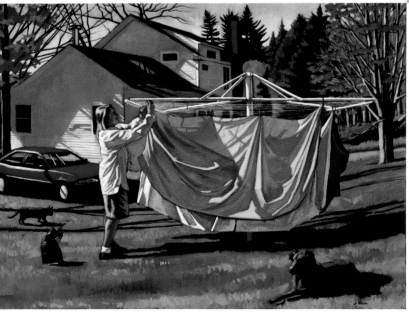

Megan With Golden Sheets
Oil on canvas. 36" × 48" (91cm × 122cm)
Collection of Pete and Kathi Bovine, Southport, NC

Aerial Perspective

The use of aerial perspective in a landscape is a marvelous way to supplement the depiction of space. The phenomena of mountains and distant objects to decrease in value (lighten) and crispness and to become more bluish or hazy has long been observed and incorporated into art. Aerial perspective in art is evident as far back as ancient fresco paintings from Pompeii. The observed effects of atmosphere in the landscape, however, gained popularity in the Renaissance with Leonardo da Vinci, and the depiction of atmospheric haze was known thereafter as *sfumato*. The general process is to show the effects of air by muting the hues and making the values lighter and less contrasting for the objects farther away from the viewer.

To assist in creating depth in a work, keep the quality of edges in mind. The general rule of thumb is to make the edges softer in the distance and more defined in the foreground.

August Morning—Stonington, Maine
Oil on canvas. 36" × 36" (91cm × 91cm)

Less contrast and intensity in the distance
Linear perspective is at work here, as well as elements of aerial perspective in the atmosphere and bluish islands in the distance. As the layers of hills or islands at the horizon recede into space or go toward the point where the sky and water meet, they gradually get lighter and grayer, having less contrast and less intensity.

Road to the Valley—Homets Ferry, PA
Oil on linen. 54" × 60" (137cm × 152cm)

Progressively lighter layers of value
The air at this time after sunset on a winter evening has a softening effect on the land. I have reserved the darkest darks and the most contrast for the road and trees in the foreground. Then, the barn, trees and bales in the middle ground are blocked in with dark to middle values. As we move further into the painting, the hill beyond the buildings is depicted with bluish gray, where the values are distinctly lighter. Then each layer of mountain beyond continues to be portrayed with lighter overall value.

Gaining New Inspiration From a Familiar Location

I sometimes speculate that 80 percent of creating a landscape painting consists of actively looking for the right spot. Sometimes it happens through a chance discovery, but more often it takes a concerted effort. So, when I can return to a dependable view, it makes things a tad easier.

To interpret the same location more than once is a wonderful way to prime our creativity or stretch our capacity to find new approaches. Just changing our vantage point will introduce new possibilities, and it will be up to us to evoke or coax out the beauty and intrigue.

Changing the time of day is one good way to obtain an entirely new work from the same scene. Revisiting a scene in the morning, afternoon or nighttime can reveal many new aspects to the same scene. Changing the season shown is another way to alter the scene and an opportunity to modify our impression. Changing the lighting conditions is another way to portray a scene differently. For example, incorporating dark storm clouds with dramatic sunlight streaming through, or visualizing the same scene under blue skies will offer two interesting options to explore.

I've painted this particular stretch of road in Pennsylvania (near Wyalusing) perhaps a dozen times or more. It presents a wonderful vista with infinite possibilities. Here, we will compare three different interpretations of this landscape.

Summer Light Through Trees— Homets Ferry, PA
Oil on canvas. 30" × 60" (76cm × 152cm)
Collection of Linda Graves, Ithaca, NY

Conveying the last light rays of a summer day
In this work, the light was visualized as it may have been. My primary interest was to convey the summer light as the final rays of the day illuminated the land with a warmth and glow. I used light and midtone warm colors contrasted with the dark and less chromatic areas of trees. In the fields, the shadow areas were also kept warm, with Yellow Ochre, Chromium Oxide Green and Raw Umber. The road contains more chromatic violet hues to contrast with the warm hues elsewhere.

The hay bales were invented to add interest to the foreground. They also add another level to the progression of trees, house, road and mountains, all leading back in space.

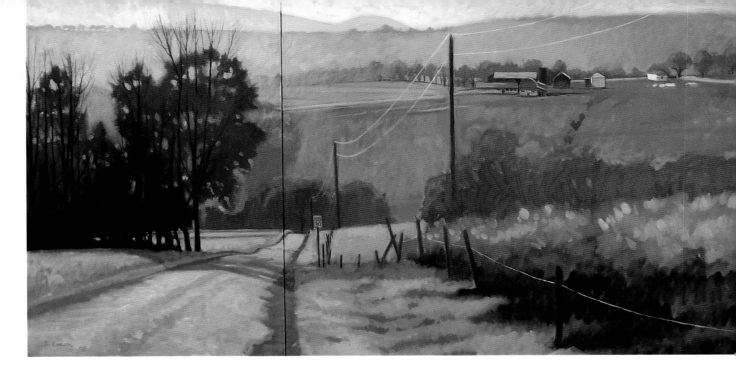

Homets Ferry Autumn Evening Light
Oil on canvas. 30" × 64" (76cm × 163cm) diptych

A change of season and a dramatic dyad

This view leads down the same road as shown on page 114, but farther down in the valley. The diptych format draws attention to the overall composition and distribution of shapes. The light is again the source of inspiration; however, I wanted to convey the light through an arrangement of color that incorporated the offset complements turquoise and rust. The orange and russet colors of the masses of trees are paired against the mostly bluish green of the hillside.

Homets Ferry Winter Evening
Oil on panel. 22" × 48" (56cm × 122cm)

Arranging colors and lines to point the way to the focal point

This winter view shows rows of earth coming up through the snow, leading the eye up to the house on the horizon. The snow and field patterns also bring out the slightly rolling topography. The high-chroma color around the sun and trees contrasts with the grayish white of the snow in shadow and the dormant ochre/umber grass, along with the house and other buildings, which are all supporting actors that lead up to the sun.

Seaside Sky: Keeping Clouds in Perspective

The main goal in this demonstration is to understand how land and sky can be portrayed to work in concert while augmenting the overall pictorial space. The clouds become an exercise in perspective, and you will see how they provide a type of corollary perspective that supplements the spatial relationship described by land and sea.

MATERIALS

SURFACE: Stretched medium-weave linen, 26" × 30" (66cm × 76cm)

PAINT COLORS: Burnt Sienna • Burnt Umber • Cadmium Orange • Cadmium Red Light • Cerulean Blue • Chromium Oxide Green • Cobalt Blue • Naples Yellow • Permanent Rose • Phthalo Green • Prussian Blue • Raw Umber • Ultramarine Blue • Venetian Red • White • Yellow Green (Utrecht) • Yellow Ochre

OTHER: Neutral Gray acrylic paint (Utrecht)

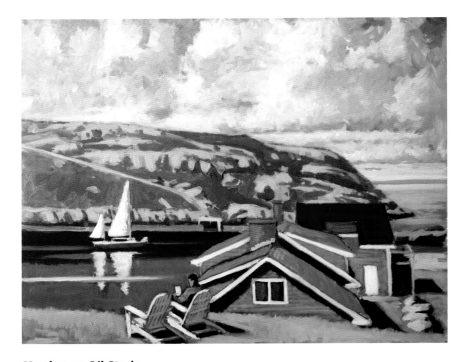

Monhegan Oil Study
Oil on panel. 14" × 16" (36cm × 41cm)

Oil study

This plein air study was done on location in Monhegan, a picturesque island off the coast of Maine where many other artists have sought the muse, including American painters Robert Henri, Winslow Homer, Rockwell Kent and the Wyeths. Painting on location allows you to experience the scene directly and glean important impressions that would not come from photos alone.

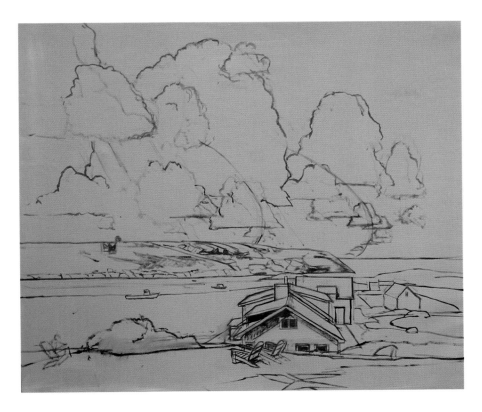

1 Shift the focus to the sky

Tint the surface with Neutral Gray acrylic first. Use Burnt Umber and sometimes Burnt Sienna to sketch in the image. I made significant changes in the composition from the original study, including altering the eye level to be much lower on the picture plane. The distribution of shapes has changed to make the sky and clouds the main emphasis in the painting. Perspective comes into play in a significant way because of the roof lines of the houses.

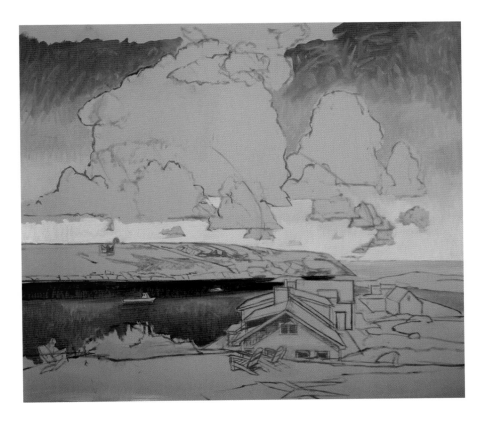

2 Block in the sky and water

Begin blocking in the sky with thin passages of blue around the clouds, using a mixture of Ultramarine Blue, Cobalt Blue and white. For the water, keep the values darker, using Prussian Blue, Ultramarine Blue and Burnt Umber.

As the sky nears the horizon, warm up the blue by adding Cerulean Blue as you lighten with white. Do a similar process with the water, lightening and warming as the water approaches the horizon.

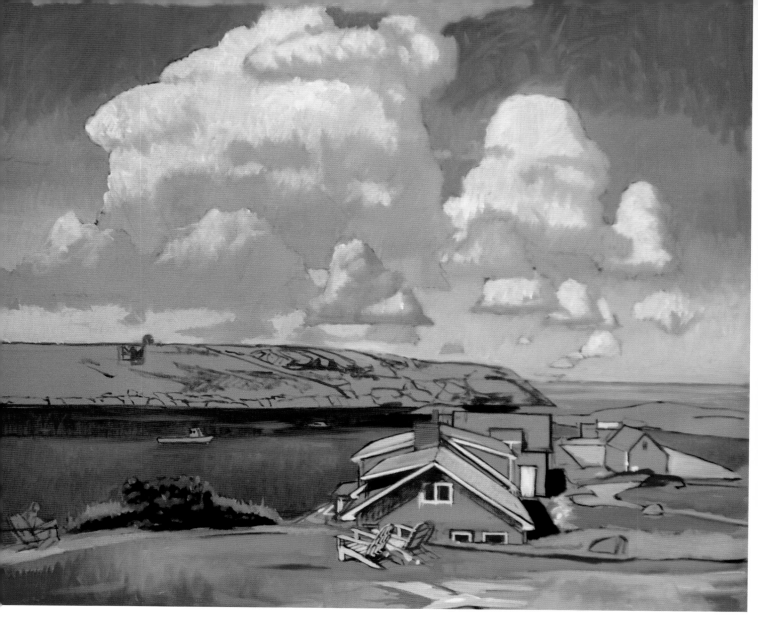

3 Develop the clouds and the foreground

Start articulating the form of the clouds with white. In the clouds, I will often add small amounts of Naples Yellow to the light areas to create a warmer tone, resulting from the sun. In the shadow areas of the clouds, use equal but small amounts of Phthalo Green and Permanent Rose mixed with white to produce a neutral gray. Depending on how much of the green or rose is used, the resulting color will be either turquoise-like or mauve-like.

Paint the foreground grass with Yellow Ochre, Yellow Green (Utrecht) and some Naples Yellow. For the warmer spots, use Chromium Oxide Green with white and Yellow Ochre to produce a warm green. While adding the color in masses, develop the form of the hill.

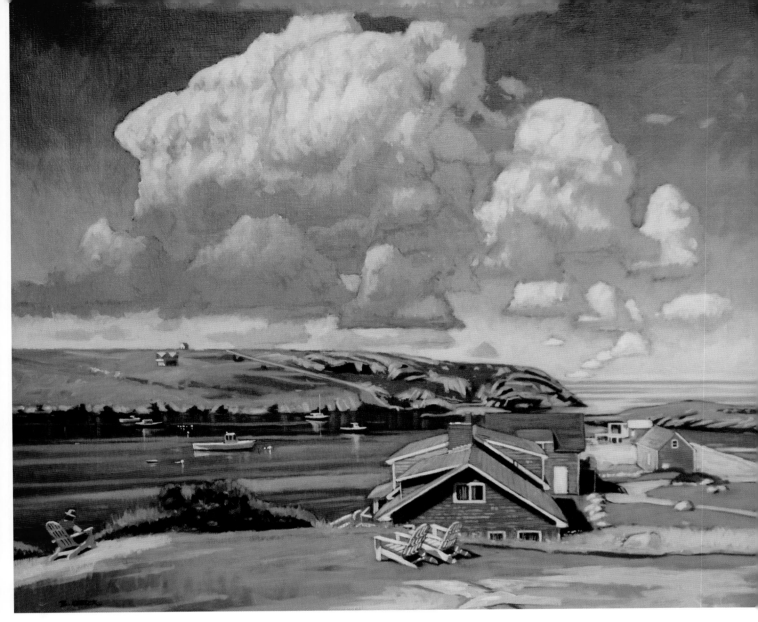

Monhegan Sky
Oil on linen. 26" × 30" (66cm × 76cm)

4 Add dimension to the clouds and water

Build up the highlights in the clouds and model their form while doing so to give them a three-dimensional, sculpted quality. Add another layer of paint to the sky, with darker values at the top, using Cobalt Blue and Ultramarine Blue with less white. As the sky nears the horizon, lighten it with white and Cerulean Blue, while softening and diffusing the edge where the water and sky meet.

Deepen the contrast and add details as you work all over the painting. The red chimney and the shirt of the woman reading are "punched up" a tad by making them more intense with Cadmium Red Light, Venetian Red and white. The chimney in effect becomes the brightest note of color in the composition, with the woman to the left a sort of counterpoint or secondary interest. Lighten and warm the green hue of the foreground grass with Naples Yellow added to Chromium Oxide Green and white. Develop the background land with even warmer colors, using Yellow Ochre, Cadmium Orange and white in the light grassy areas. In the darker areas near the rocks, use Raw Umber, Burnt Umber and some white. Make sure to maintain and define the areas of rocky terrain. To help create spatial depth in the water, add horizontal bands of lighter color.

Cityscape: Perfecting Street Scene Perspective

In this cityscape, our goals are to show the meeting of nineteenth-century architecture and today, showing old buildings contrasted in the reflections on a modern car, while demonstrating one-point perspective. In this scene, the midday sun was also creating interesting effects and bringing out the geometric designs of the buildings, which contrasted with the fluid curvilinear reflections on the car.

MATERIALS

SURFACE: Stretched medium-weave linen, 26" × 30" (66cm × 76cm)

PAINT COLORS: Alizarin Crimson • Burnt Umber • Cerulean Blue • Chromium Oxide Green • Cobalt Blue • Naples Yellow • Permanent Rose • Phthalo Green • Prussian Blue • Ultramarine Blue • Venetian Red • White • Yellow Ochre

OTHER: Raw Sienna acrylic paint

1 Mind perspective as you sketch
Working on a canvas tinted with Raw Sienna acrylic, begin the drawing with Burnt Umber paint. The drawing stage here requires a lot of work and attention to details. This is essentially one-point perspective, with the vanishing point indicated with an "X" above the car's luggage rack on the passenger side.

2 Establish a light to start
Start the painting stage by blocking in the light of the building on the right (I used Chromium Oxide Green, Naples Yellow and white to achieve the desired hue). Also begin to work on the signage. I particularly like the slant of light coming through the drugstore sign.

3 Block in and mass the darks

Start blocking in the shadow areas. This scene lends itself to painting because of the nice division of light and dark. It is helpful to try to mass the darks so they are more or less consistent in value. Use Burnt Umber with Phthalo Green and sometimes Venetian Red to create a sort of low-chroma, even nondescript shadow. For shadows, sometimes we increase the intensity as the Impressionists were known to do; at other times, as I did here, we exaggerate the mystery by keeping them less defined, with thinner paint and less detail.

4 Start the car

Start to work on the reflected surface of the car in the foreground. The patterns of distorted reflections in the car add to the appeal of this image. Use a variety of blues, but keep them toned down or of minimized intensity. In the shadow area, use Ultramarine Blue with Burnt Umber and perhaps some Prussian Blue. In the light areas, the blue is a mixture of Cerulean Blue, white and Alizarin Crimson. In the windshield, the mauve is achieved by adding more Alizarin Crimson or Permanent Rose.

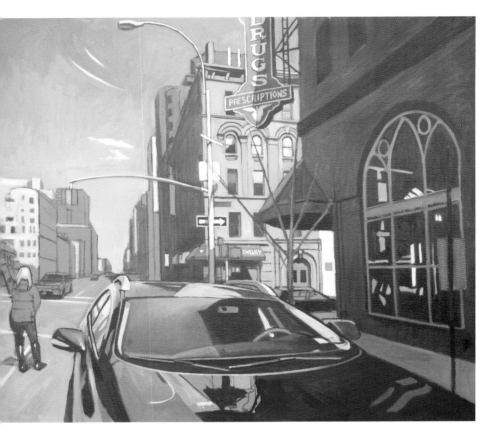

5 Begin the sky and street

Now block in the large areas of the sky and the street. While painting these, it is important to keep in mind the value relationships, determining what is light against dark or dark against light. For the sky, use Cobalt Blue, Cerulean Blue, Ultramarine Blue and white in varying degrees. The street is sunlit and light in value, a warm gray comprised of white, Burnt Umber, Chromium Oxide Green and Yellow Ochre.

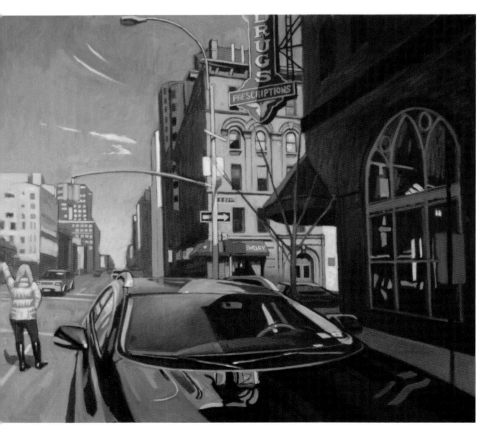

6 Work on details and building contrast

Begin developing the woman hailing the cab and articulating details in the buildings and the car in the foreground. For the car, add some darker accents and increase the chroma in certain colors. Now articulate some of the details of the reflected buildings in the hood. The orange in the hood of the car in step 5 was still the undercoat showing through, and here I have painted this area. The steering wheel remains as the tinted undercoat and serves well as it is, with only minor additions. Push the highlights, adding glints in the mirror and the trim of the car.

The sky has had several layers of pigment added, and at this stage you want to move to a cooler blue, which means adding more Ultramarine Blue while darkening the value at the top. Darken the building on the right using Burnt Umber and perhaps some Venetian Red.

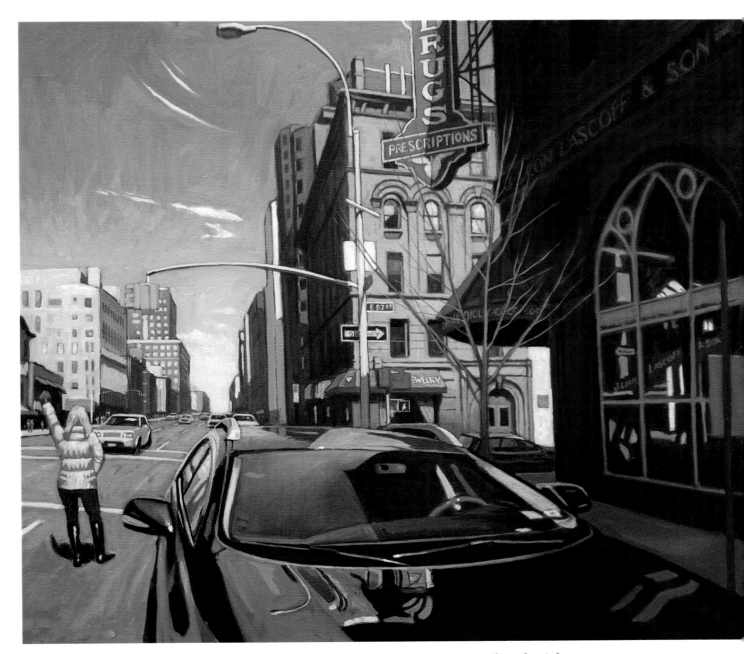

Hailing the Cab
Oil on linen. 26" × 30" (66cm × 76cm)

7 Bring the forms to fruition

In this final stage, continue to develop details and model form. Add some color to the cabs in the background and interject some lavender-like colors into the pavement. Make the sidewalk on the right darker and cooler with Ultramarine Blue and Burnt Umber, to contrast it with the sunlit street.

One of the challenges of this painting was that I was using two references that were not in complete agreement. This necessitated manipulating and inventing the perspective in the car in order to get the orthogonals to lead toward the vanishing point. There is somewhat of a distortion caused by the wide-angle lens used for the photo reference, which in this case warps and makes the perspective lines curvilinear.

Index

Painting on the go

The photo on the opposite page shows how I use a portable Soltek easel and various supplies for oil painting, which all fit on the rack of my bicycle. I usually take two elongated-rectangle panels of the same size and two matching off-square panels to offer the option of two different formats. Then, at the end of the painting session, the wet panel is placed against the back of the unused panel for the return trip.

Dedication

To Honeychurch.

Acknowledgments

There are many people to thank for seeing this book come to fruition. There were several editors who looked over early drafts of some of the text, and their honest input was essential to forging ahead. These editors who patiently offered their expertise include Elissa Wolfson, Hilary Lane and Linda Graves. The editors at North Light Books are to be praised as well; in the early stages these editors included Vanessa Weiland and Mary Bostic, who kept the project going. Scott Ballard also worked with me over many years, compiling images and text in several early drafts, and without his technical know-how and computer skills, this book would not be possible. To see the project really come to life, however, the final editor at North Light Books, Stefanie Laufersweiler, provided the polish and finesse to fine-tune the manuscript and overall concept into one that would reach and communicate with art students and the general public.

 Other fine North Light Books are available from your favorite bookstore, art supply store or online supplier. Visit our website at fwmedia.com.

18 17 16 15 14 5 4 3 2 1

DISTRIBUTED IN CANADA BY FRASER DIRECT
100 Armstrong Avenue
Georgetown, ON, Canada L7G 5S4
Tel: (905) 877-4411

DISTRIBUTED IN THE U.K. AND EUROPE
BY F&W MEDIA INTERNATIONAL
Brunel House, Forde Close, Newton Abbot, TQ12 4PU, UK
Tel: (+44) 1626 323200, Fax: (+44) 1626 323319
Email: enquiries@fwmedia.com

DISTRIBUTED IN AUSTRALIA BY CAPRICORN LINK
P.O. Box 704, S. Windsor NSW, 2756 Australia
Tel: (02) 4560-1600 Fax: (02) 4577 5288
Email: books@capricornlink.com.au

ISBN-13: 978-1-4403-2932-6

Art on the title page:
Spring Hill Light
Oil on canvas. 36" × 40" (91cm × 102cm)
Private collection

Edited by Stefanie Laufersweiler
Production edited by Brittany VanSnepson
Cover designed by Amanda Kleiman
Interior designed by Brianna Scharstein
Production coordinated by Mark Griffin

METRIC CONVERSION CHART		
CONVERT	TO	MULTIPLY BY
Inches	Centimeters	2.54
Centimeters	Inches	0.4
Feet	Centimeters	30.5
Centimeters	Feet	0.03
Yards	Meters	0.9
Meters	Yards	1.1

about the Author

Expressing and describing the beauty of light has been the focus of Brian Keeler's career in painting, which includes landscape, the figure, portraits, still life and allegorical work. Depicting the "topography of light" is the way he likes to describe this process, as this phrase communicates the way light plays across forms in the multifaceted expressions of both the light and the subjects. In a certain sense, however, the light actually becomes the subject for Brian, and the scene or depiction takes on a secondary or supporting role. He often chooses the *golden hour* as the time for portraying the motifs he selects, as this late afternoon or early morning light accentuates the drama of any given scene. His figurative painting and other genres also incorporate a marvelous appreciation for the way light can reveal the world to us.

Among other artists, patrons and the general public, Brian is known as a colorist, as it is the quality of his color that is one of the memorable aspects of his well-crafted works. His art also combines a unique sense of composition, proportional harmonies and draftsmanship, as his oil paintings, pastels and watercolors show an orchestration of the overall relationships.

Brian combines these aesthetics of light and structural compositional dynamics in his work and in his teaching and writing, as he shares his love for painting in workshops in the United States and abroad, most notably in figure painting and plein air courses taught in Italy. He has become a passionate student of the Italian Renaissance over his more than twenty years of teaching and traveling in Italy, sharing these art history insights in slide lectures as well as incorporating some aspects of the classics into his own allegorical works.

Brian Keeler is the son of a Sunday painter and newspaper editor, the late William W. Keeler, whom he credits for sparking his initial interest in art. Brian received his early training at a small art school in southern Pennsylvania, York Academy of Arts. His paintings, which have been featured in *American Artist* magazine, have received numerous awards over a long and productive career, and his work is featured in numerous private, business, corporate and museum collections. Brian lives in Ithaca, New York, and maintains a studio in his hometown of Wyalusing, Pennsylvania, where he founded the Blue Heron Art Gallery. In Pennsylvania, his work has been represented at the Laura Craig Gallery in Scranton and the Rodger LaPelle Galleries in Philadelphia, and in New York, the West End Gallery in Corning and the Titus Gallery in Ithaca. Visit his website at briankeeler.com.

Ideas. Instruction. Inspiration.

Receive FREE downloadable bonus materials when you sign up for our free newsletter at artistsnetwork.com/Newsletter_Thanks.

Find the latest issues of *The Artist's Magazine* on newsstands, or visit artistsnetwork.com.

These and other fine North Light products are available at your favorite art & craft retailer, book-store or online supplier. Visit our websites at artistsnetwork.com and artistsnetwork.tv.

Follow North Light Books for the latest news, free wallpapers, free demos and chances to win FREE BOOKS!

Visit artistsnetwork.com and get Jen's North Light Picks!

Get free step-by-step demonstrations along with reviews of the latest books, videos and down-loads from Jennifer Lepore, Senior Editor and Online Education Manager at North Light Books.

Get involved

Learn from the experts. Join the conversation on